AFTER THE RUINS | 1906 AND 2006

AFTER THE RUINS

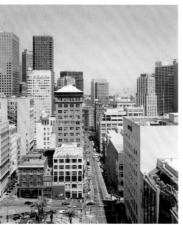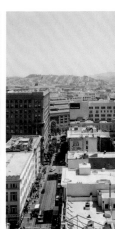

**UNIVERSITY OF
CALIFORNIA PRESS**
BERKELEY LOS ANGELES LONDON

**Fine Arts
Museums of
San Francisco**

1906 AND 2006

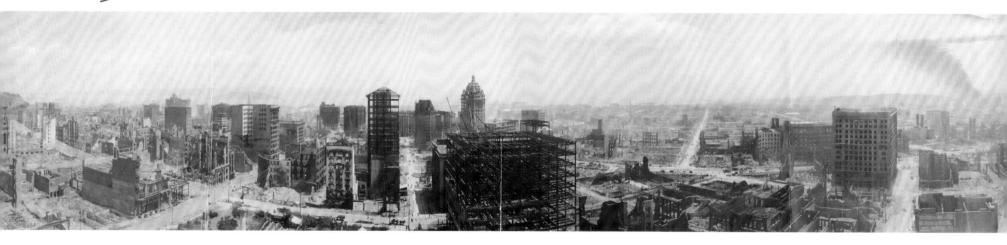

REPHOTOGRAPHING THE SAN FRANCISCO EARTHQUAKE AND FIRE

MARK KLETT WITH MICHAEL LUNDGREN

ESSAYS BY PHILIP L. FRADKIN AND REBECCA SOLNIT
AND AN INTERVIEW WITH THE PHOTOGRAPHER BY KARIN BREUER

Published on the occasion of the exhibition
After the Ruins, 1906 and 2006:
Rephotographing the San Francisco Earthquake and Fire
organized by the Fine Arts Museums of San Francisco

Legion of Honor
December 17, 2005, to June 4, 2006

University of California Press, one of the most distinguished university presses in
the United States, enriches lives around the world by advancing scholarship in the
humanities, social sciences, and natural sciences. Its activities are supported by the
UC Press Foundation and by philanthropic contributions from individuals and institu-
tions. For more information, visit www.ucpress.edu.

University of California Press
Berkeley and Los Angeles, California

University of California Press, Ltd.
London, England

© 2006 by the Fine Arts Museums of San Francisco

Library of Congress Cataloging-in-Publication Data

Klett, Mark, 1952–
 After the ruins, 1906 and 2006 : rephotographing the San Francisco earthquake
and fire / Mark Klett ; with Michael Lundgren ; essays by Philip L. Fradkin and
Rebecca Solnit, and an interview with the photographer by Karin Breuer.
 p. cm.
 "Published on the occasion of the exhibition *After the ruins, 1906 and 2006 :
rephotographing the San Francisco earthquake and fire,* organized by the Fine Arts
Museums of San Francisco, Legion of Honor, December 17, 2005, to June 4, 2006."
 Includes bibliographical references.
 ISBN 0-520-24434-6 (cloth : alk. paper) — ISBN 0-520-24556-3 (pbk. : alk. paper)
 1. San Francisco Earthquake, Calif., 1906—Pictorial works—Exhibitions.
2. Fires—California—San Francisco—History—20th century—Pictorial works—Exhi-
bitions. 3. San Francisco (Calif.)—History—20th century—Pictorial works—Exhibi-
tions. 4. San Francisco (Calif.)—Pictorial works—Exhibitions. 5. Repeat
photography—California—San Francisco—Exhibitions. 6. Fine Arts Museums of
San Francisco—Exhibitions. I. Lundgren, Michael. II. Fradkin, Philip L. III. Sol-
nit, Rebecca. IV. Breuer, Karin. V. Fine Arts Museums of San Francisco.
VI. Legion of Honor (San Francisco, Calif.). VII. Title.

F869.S343K58 2006
979.4'61051'0074—dc22

 2005018469

Manufactured in Singapore

15 14 13 12 11 10 09 08 07 06
10 9 8 7 6 5 4 3 2 1

The paper used in this publication meets the minimum requirements of ANSI/NISO
Z39.48–1992 (R 1997) *(Permanence of Paper).*

CONTENTS

FOREWORD

The Fine Arts Museums of San Francisco are pleased and privileged to host this major exhibition on the centennial of the 1906 San Francisco earthquake and fire. Mark Klett's intriguing pairings of archival photographs of the 1906 city and its environs with his own photographs, taken in the same locations almost one hundred years later, attest to the remarkable change in our urban environment. They also demonstrate the significant progress of photography as an artistic form in the twentieth century.

The Museums have been linked to the growth of both the city of San Francisco and the art of photography over the last hundred years through an ambitious program of museum building and support of important photographic groups and individual talent. Exhibitions at the M. H. de Young Memorial Museum from the 1930s through the 1960s, notably *Photographs by Group f64* (1932) and *Ansel Adams: Forty Years of Photography* (1963), were milestones in museum and city history. The California Palace of the Legion of Honor likewise played an important role, one from which we still benefit today. In 1942, the museum acquired a sizable number of photographic prints and negatives from the estate of Arnold Genthe (1869–1942), including a group of over 125 cellulose nitrate negatives, all taken soon after the earthquake of April 18, 1906. In 1956, on the fiftieth anniversary of the disaster, the Legion commissioned Ansel Adams to select and print some of these negatives for a commemorative exhibition. Mark Klett has chosen many of the same Genthe images, as much for their rephotographic potential as for their inherent beauty.

Although not by Genthe, one of the images that Klett has chosen is particularly meaningful to me. It shows the band shell in the Music Concourse of Golden Gate Park, damaged in 1906, which Klett rephotographed in 2004, when the band shell was fenced off for construction of the new de Young (see plates 42A and 42B). This pair of images also evokes the changes that the Fine Arts Museums have undergone during my eighteen-year tenure as director, a position I assumed only two years before the 1989 Loma Prieta earthquake. The temblor caused significant damage to the infrastructure of the city and to many public buildings, including our two museums. Just as in 1906, the process of rebuilding was long and arduous. From 1992 to 1995 the Legion of Honor closed for seismic retrofitting and extensive remodeling due to its vulnerability to future earthquakes. In 2001 the M. H. de Young Memorial Museum closed for the same reasons, to be demolished and reconstructed on its historical site in Golden Gate Park. It opens in 2005 as the de Young—a new, architecturally acclaimed museum reinforced with state-of-the-art seismic technology enabling it to withstand a quake with a magnitude as great as that of 1906.

I leave the Fine Arts Museums in December of this year with a great sense of civic pride in the revitalization of the Fine Arts Museums of San Francisco since 1989, and I salute the many San Franciscans who, since 1906, have contributed to the architectural achievements and vibrant cultural life of this great city.

Harry S. Parker III DIRECTOR OF MUSEUMS | APRIL 2005

ACKNOWLEDGMENTS

Projects like this are as much about collaboration as about ideas. In October 2002, Philip Fradkin sent me an e-mail asking if I would be interested in rephotographing the amazing set of earthquake photos he had seen at the Bancroft Library at the University of California at Berkeley. I knew Philip by reputation and took the question seriously, agreeing to visit him in Point Reyes to discuss it—albeit somewhat reluctantly, as I was already in the midst of two rephotography projects.

After two days with Philip at the Bancroft, I was convinced of the project's worth, in large part because Philip's passion for the photographs was so contagious. Philip not only proposed the idea but also worked in various roles to make sure the project was completed. At times, he was historian, agent, chauffeur, guard, assistant, host, advocate, and advisor. When we started, I had no idea that the project would become as interesting as it did, and it grew largely because of Philip's unwavering commitment.

At first, the research was focused on the entire San Andreas Fault line; not until the photography began did the city of San Francisco become the real target. My collaborator behind the camera, Mike Lundgren, helped to create that transition in focus. Mike started as an unpaid assistant. His technical abilities proved formidable, but it soon became clear that he was contributing to both techniques and ideas. We worked together at every site during what amounted to weeks of fieldwork in the city, and his methods quickly became part of our combined working process. These pictures look the way they do because of his involvement.

As landscape photographers, Mike and I felt out of place on downtown streets. Fortunately, Rebecca Solnit accepted my invitation to join us. San Francisco is her city, and on this project she was not only a writer but also an able guide. Her contacts opened doors for us, and more than once her streetwise presence proved an important asset. Her ability to make far-reaching connections between history and ideas became instrumental in the development of the visual work.

Photography of this kind depends on being on site, and friends and colleagues made that both possible and comfortable. Philip and Dianne Fradkin opened their house, backyard tent, and Volkswagen van to us; and Dianne cooked wonderful meals for the street-weary. Robert and Walker Dawson and Ellen Manchester provided beds in their home and offered stimulating ideas as the work progressed. Alex Fradkin and Heather Mahaney opened their home as well. Alex assisted our work on the streets and documented the process as he simultaneously talked recalcitrant building owners into giving us access to important views. Linda Connor and Michael Light also shared their homes and encouragement. We're grateful to all our friends for keeping our costs down and our spirits high. Finally, Holly Blake and Linda Samuels at the Headlands Center for the Arts put us up in their artists' quarters for many nights. The HCA offers the best organization and accommodations an artist could ask for.

Rephotography also relies on access to historical documents. Our work would have been impossible without Karin Breuer, Curator of Contemporary Graphic Art at the Fine Arts Museums of San Francisco, who threw her support behind the project from its inception and made both the exhibition and the book possible. The Fine Arts Museums hold the set of Arnold Genthe earthquake negatives that forms the most coherent vision of the 1906 disaster, and this alone could have been a substantial exhibition. We're grateful that Karin took the risk on a project that stood at first simply as an idea. Sue Grinols at the Fine Arts Museums made the Genthe images accessible to us through electronic scans. Thanks also to

Harry S. Parker III, Director of Museums, for his support of the exhibition presentation at the Legion of Honor as part of the civic commemoration of the 1906 centennial.

The holdings of the Bancroft Library were the core of the historical works rephotographed. This important collection is accessible thanks to the many photographs found in the Online Archive of California. Jack Von Euw, James Eason, and Theresa Salazar of the Bancroft Library were enthusiastic supporters of the idea from the start. They know the 1906 work and the territory it covers, and they provided research support and scanned copies of originals, tasks necessary to the completion and printing of the work.

Likewise, Stephen Wirtz of the Stephen Wirtz Gallery shared his personal collection of 1906 photographs and allowed us to copy and use them freely. Stephen has a great commitment to the often-overlooked and undervalued images that form vital historical records. Verna Curtis of the Library of Congress assisted with the panoramas in that library's collection. Other photographs came from the U.S. Geological Survey.

Gaining access to sites in the city can be difficult, and we're grateful to those who allowed us to photograph from their vantage points. This list includes the staff of the St. Francis Hotel; Tony Rude of the View Tower Apartments; Equity Office and the Ferry Tower Investors of the San Francisco Ferry Building; Chris Carlsson of the Grant Building (who gave up part of his Memorial Day to get us on the rooftop); Elena Yujuico, Office of Religious Life and the Memorial Church at Stanford University; and the National Park Service, including former ranger and historian John Martini, who helped us find site locations. Carol Prentice of the U.S. Geological Survey shared her knowledge of several rural site locations. And Mary Lou Zoback, also of the USGS, brought our work to the attention of her colleagues and the 1906 Centennial Alliance.

Another person who put her faith in the project at an early date was our acquiring editor at the University of California Press, Monica McCormick. Before she left to pursue other studies, Monica put us firmly and skillfully on course toward publication. Later we were in equally good hands with Sheila Levine, Rose Vekony, Mary Renaud, Nola Burger, Anthony Crouch, and Randy Heyman.

Finally, we are indebted to the many photographers, often unknown, from the 1906 earthquake and fire. They show that photography is always more than simple recordkeeping; it is the pathway to future dialogue.

Mark Klett TEMPE, ARIZONA

MARK KLETT, REPHOTOGRAPHY, AND THE STORY OF TWO SAN FRANCISCOS

AN INTERVIEW WITH KARIN BREUER

You are often credited with coining the term "rephotography" and with being the first and foremost practitioner of the genre because of your work on the Rephotographic Survey Project from 1977 to 1982. What was that project, and how did it define the practice of rephotography?

We might have coined the term "rephotography," but we certainly didn't invent the genre! In fact, the Rephotographic Survey Project [RSP] used the work of scientists as a model. Geologists had laid the best groundwork for accurate "repeat photography," as they called it. The basic idea was to find the locations from which historical photographs had been taken and then make new photos from exactly the same vantage points. The goal was to do the work with as much accuracy as possible. So, in addition to reproducing the camera position, accurate rephotography tried to duplicate the time of day, time of year, weather conditions, and so on in which the original photograph was taken.

The RSP's interest was in historical survey photographs from the nineteenth-century American West. These images, made during the 1860s and 1870s, were important historical artifacts that were beginning to be valued as artworks. The project began as a collaboration between Ellen Manchester, JoAnn Verburg, and myself, who combined backgrounds in photographic history, conceptual art, and science. We felt that accuracy in the work was essential to understanding physical change, but we also felt that it was key to the perception of change, by inviting comparisons between similar but different photographs. There were a total of 122 sites revisited for the project.

How has your work in rephotography evolved since that first project?

Well, I stopped making rephotographs for a long time and considered the idea done. But in 1997, I began the Third View project with Byron Wolfe,

Kyle Bajakian, and Toshi Ueshina. The collaboration later grew to include Michael Marshall and writer William Fox. We decided to find out what had happened in the twenty years since the RSP ended, and we went back into the field to make yet another set of views at the same sites. The same methods were used to make the rephotographs, but this time we expanded the methodology of the overall project. Because we were interested not only in landscape and cultural changes but also in how those changes could be perceived, much of the project was devoted to multimedia materials collected in the field, such as video, sounds, and interviews as well as images made for computers. What we did was to use the idea of rephotography to explore how both the landscape and our perceptions of it have changed. The resulting book, *Third Views, Second Sights* [Museum of New Mexico Press, 2004], is what I consider the first book of a rephotographic triptych.

As we were finishing Third View, I was approached by writer Rebecca Solnit about revisiting Eadweard Muybridge's photo sites in Yosemite. She had just finished writing her book *River of Shadows* [Viking, 2003] and was looking to understand more about his unusual mammoth plate views of the park. We teamed up with Byron Wolfe, my colleague from Third View, to form another collaboration in 2001. We started with the basic rephotographic methodology established by the RSP and also used in Third View. Our work with Muybridge quickly expanded to focus on early photos by Carleton Watkins and twentieth-century modernists Ansel Adams and Edward Weston. We found that in Yosemite one can sometimes scan a vista that includes two or more historically significant views made from the same or nearly the same vantage points. So we were able to make new panoramas and "embed" images made by different historical photographers into one scene. The result was a different kind of rephotography, a layer cake of landscape photographs made at different times.

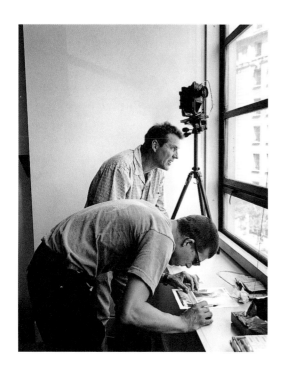

Mark Klett and Michael Lundgren rephotographing the Call Building, Market and Third Streets, 2003. (Alex L. Fradkin)

In doing this work, Byron and I felt freed from the traditions of our established techniques; and, as in Third View, we were able to steer the methodology into new territory. We became focused not only on change and perception but on the nature of time itself. There were many discussions—that's the beauty of collaborations, those in-depth discussions—that revolved around combinations of time and space, how we understand time in photographs, or don't. The book from the Yosemite project, *Yosemite in Time* [Trinity University Press, 2005], forms the second work in the triptych I mentioned. And it led to this work in San Francisco. I see this book on the 1906 earthquake as the last in this group of three different but related projects dealing with rephotographic methods.

So all my rephotographic projects share basic techniques, but the methodologies change depending on the circumstances. On a conceptual level, the underlying premise is that historical photographs are relevant only if they are brought into a current dialogue. Or, you might say that rephotography is a great way of extending a conversation about place over time.

You're starting to address my next questions. How is rephotography more than just the re-creation of a historical shot? How does that relate to San Francisco, and how did this project get started?

I should provide some background. The work on the 1906 earthquake began when Philip Fradkin contacted me in December 2002 about the photos he'd found while doing research at the Bancroft Library at Berkeley.

I was skeptical at first about getting involved in yet another rephotography project, but the subject interested me. I had a longstanding relationship to San Francisco, its organizations and artists. Combined with that, I'd had personal experience with such a disaster in Japan in 1995, when I witnessed the devastation of the Kobe earthquake. So I was predisposed to the idea, and the early photos of the city's destruction were tragically familiar. On an abstract level, I also wondered what it might be like to work in an urban area. To do this, I needed help, so I asked a former graduate student of mine at Arizona State University, Mike Lundgren, to assist me. As we worked together, he became less an assistant and more a collaborator, contributing to the ideas and methods.

In fact, shortly after Mike and I started to make the rephotographs in May 2003, it became clear that interpreting the larger scenes before us was more interesting than re-creating the little slices of space that the original photos recorded. That is, the 1906 pictures carved a small window out of the very large space at which the camera pointed, and now that larger space has been developed in a way that the original photographer could not have thought possible. Using a wider-angle lens than we would have needed to simply repeat the original view allowed us to record more of the contemporary context in which the original photo now exists. The overlap between that old window in space and the new one became our focus, and it dictated a slight change in the way the photographic pairs were presented. In this project, the newer photograph is displayed on the left side of the diptych, in the position usually reserved for the image considered "first" in time. This reversal was intentional, a way of calling into question the direction of the flow of time. A left-to-right reading implies the most common understanding of a disaster, that a built environment is destroyed. Except that the left side hasn't been destroyed, at least not yet.

This change in order, read left to right or right to left, is of course a reference to our knowledge that earthquakes are not one-time events. But more than a reminder of the power of nature, or a warning against arrogance in the face of it, I also think it's a way to contemplate how we understand time and our relationship to the past. At the outset, it seems that the San Francisco of 1906, *that* San Francisco, is no longer with us—an almost unimaginable place that exists only in aging photographic artifacts. The city is now so different that we have to search for evidence of 1906 in the present if we hope to find it. Why should we even care to do so?

I find it haunting that details still exist that seem to prove that the two spaces and times are related. Buildings, monuments, objects that are the same can be found in each photo pair. If not for this evidence, the disaster of 1906 would appear to have moved to a condition of the past, harmlessly out of the way. Instead, there's an edgy reminder of continuity and a suggestion that we're not immune to the kind of city those pictures represent. Just as aging photos speak to us of places and times that no longer exist, the photos that represent the vigorous city of today may also do the same. The past, the present, and the future lie uncomfortably close together in a curve of probabilities; and they are not necessarily connected by an implied linear flow—a flow toward stability or greatness that a simple 1906 to 2006 comparison would suggest. Either moment appears equally transitory. This is not a prediction of doom. If anything, I think the pictures ask us to become aware of the extraordinary qualities of our own distinct moment in time. But it is a realization that a particular future is not guaranteed by the flow of time in any given direction.

Is one of the goals of rephotography to get the viewer to consider change over time?

Yes, rephotography is particularly good at asking viewers to consider their relationship to time and change. I used to think that change was the outcome of time passing, that change happened because the movement of time was a constant. But after years of rephotographic work, I think differently. Now I believe that change is not the result of time, but rather the true measure of it. Time in this equation is not constant at all. Of course, there's more than one way to measure time. But so many of our basic instincts as human beings involve gauging change through visual evidence that I would argue it is an important skill for survival. What can we see differently as we learn to gauge time another way? Will that affect the decisions we make? Those are the questions that interest me.

So rephotographs function as a kind of memento mori when they are paired with images from a time long past? Do they invite us to consider that our moment will soon be past too? How much do they ask us to project to the future, one hundred years from now?

They call on us to position ourselves relative to the past, the present, and the future, whatever they may be. One idea is that by changing the relationship between the past and the present, by considering new interpretations of both, we are actually changing the past as well as the potential for our future. As I suggested earlier, the relationships among what we consider past, present, and future are matters of less certainty than might be expected. So is the position of the present. To use an analogy, time might often appear to be like a river flowing in one direction. Given two points—past and present—a certain trajectory toward a future might be assumed. But even in real life the time/river model isn't entirely predictable. For example, the river moves more quickly in the center than at the edges; and when it hits a rock, there are eddies where the water can actually flow backward. Where in the river are we right now—moving fast at the center, slowing at the edges, swirling backward in an eddy? For me, the photos are combinations of moments in time, and what they do is ask us to contemplate our position. They provide perspective and, in doing so, are calls to awareness and responsibility.

Does rephotography have an environmental agenda? That is, are your rephotographs of urban San Francisco to be considered as visual commentary on overdevelopment and congestion? I'm thinking here of two specific pairs: the photos taken at the corner of Stockton and Geary [plates 16A and 16B], and those showing Montgomery and Bush Streets [plates 12A and 12B].

There's no one-sided statement here about the environment of the city. But some of those issues are unavoidable in looking at the photos, and I think they ask to be considered. Depending on your viewpoint, the congestion could be either a healthy sign of progress or evidence of market forces gone awry. A debate over different perceptions, if it happens, is a good thing. But I'm equally interested in the possibility that the photographs will become part of a long-term historical dialogue. I wonder how viewers one hundred or two hundred years from now will interpret our culture from these scenes?

On the other hand, it's pretty clear that San Francisco in 1906 wasn't exactly a pristine wilderness; in fact, it was a thriving urban area. A couple of examples that show this effectively are Arnold Genthe's photograph of the fire from Clay Street [plate 22B] and the photos from California Street [plates 13A and 13B] in which you've framed the 1906 site within the larger format of today's landscape [see page 7]. Could you comment on that technique?

The old and new images are enlarged to the same scale, which is something Mike and I discovered we could do at most sites because the earlier images were made with "normal," or telephoto, lenses, in comparison to our wider-angle lenses that can take in more space. It's an effective technique for describing the new context for the first view.

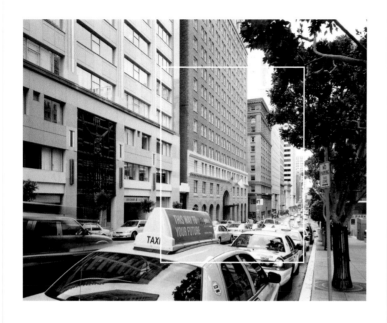

This example illustrates the relation of the rephotographs *(left)* to the original photographs on which they were based *(right)*. The two images are reproduced at the same scale, and the pairs are composed so that spaces common to both occupy the same position on each page. Here a rectangle frames the location of the original scene within the space of the rephotograph.

Later, we hit on the idea of using the rectangle to frame the earlier position in space during proofing as a way of indicating that the smaller, older image exists within the larger frame of the contemporary view. This helps orient viewers in interpreting the same spaces, but I'm not so keen on it as a formal device. It looks rather didactic, so unless it seems necessary, I'd rather see the contemporary view unframed.

How many paired photographs were chosen because you knew dramatic changes had occurred? Also, in certain pairings—"The view from the Ferry Tower" and "Market St. from Ferry" [plates 2A and 2B], "The edge of Lafayette Park" and "Lafayette Square at dusk" [plates 24A and 24B], and "Moving van, Sacramento Street near Powell" and Genthe's untitled photo of residents watching the fire from Sacramento Street [plates 21A and 21B]—there is a distinct sense that you saw something in the site today that made the photograph more interesting. And it was something that you couldn't have anticipated—you saw something beyond the straight re-creation. Are those the kinds of photographs you hope for? Do you consider them more successful than others?

Well, the change is almost always dramatic in San Francisco, so there were a lot of pictures to choose from! But from the beginning, my goal was to make interesting photographs at each scene. We always faced constraints, of course. We worked from the original photographer's van-

tage point and more or less at the same time of day. But there were a lot of other decisions that made the photograph more or less interesting as a contemporary view—people interacting, cars and vehicles moving, momentary events, and so forth. These layered images seemed more successful.

Did you know, for example, that if it hadn't been for the Loma Prieta earthquake of 1989, which resulted in the destruction of the Embarcadero Freeway, your photograph of the Ferry Building from the southwest [to pair with a 1906 photograph by George McComb] couldn't have been taken? The Ferry Building would have been obscured by the freeway from that vantage point.

No, I didn't know that. Actually, it might have been a more interesting rephotograph before the freeway came down. That's the kind of perspective that a San Francisco resident would have that we didn't. I admit that we're outsiders coming to make these photographs, sort of visual carpetbaggers. On the other hand, rephotography is a unique way of getting to know a place. Even long-term local residents can learn much by studying the old photos and piecing together the arrangements of space they represent. My best orientation to the present-day San Francisco came from the visual footprints of 1906.

Interview with Karin Breuer

The Ferry Building seen from the southwest in 2004. Palm trees grow where the Embarcadero Freeway once stood. (Mark Klett with Michael Lundgren)

floors, which had been crushed by the ones above. I walked through residential neighborhoods on a sea of charred remains, sometimes pausing to realize I was standing in what had been someone's kitchen or in their bathtub. The images were mixed in my mind with views of the aftermath of the atomic bombs dropped on Hiroshima and Nagasaki. Because it was the fiftieth anniversary of the end of the war, those images were prevalent.

And when I saw the photographs of 1906 San Francisco, they were immediately recognizable. They spoke to the same forces of disaster. The Japanese have a saying, *shi kata ga nai,* which means nothing can be done. And I learned that they live their lives every day with the potential of destruction from both natural and human causes as a kind of national background. In fact, they seem to have hope in spite of it. How do we address the same potential here in our own country? Some of my San Francisco friends exhibit the same realization and acceptance, a position that I both admire and find frightening. In a post-9/11 world, it's an approach to life not limited to earthquake-prone environments. This tension drew me emotionally as much as any fragment of history.

Your 1990 rephotograph of Eadweard Muybridge's 1878 panorama of San Francisco gave you an urban project for the first time [published by Bedford Arts in book format in 1990 as *One City/Two Visions*]. Did that experience influence your decision to rephotograph 1906 earthquake sites?

Yes, certainly. The Muybridge panorama was an important historical document as well as a technical feat for its day. Repeating it posed logistical challenges for me, including gaining access to the vantage points now in the Mark Hopkins Hotel. What surprised me, however, was how much the city had changed between 1878 and 1906. Almost none of that Muybridge panorama made it into the late twentieth century.

You mentioned that you had been in Japan during the 1995 Kobe earthquake. Did that experience play a role in your decision?

In January 1995, I was living in Kyoto with my family on a Japan/U.S. Friendship Commission Artist's Fellowship. We had barely been there two weeks when we were awakened by a forceful earthquake, with a magnitude of 6.9. The epicenter was in Kobe, fifty miles away. Thousands of people were killed, and tens of thousands were injured and left homeless. It was almost a month before I could get to Kobe to see the damage, but once the trains and buses began to run to the city outskirts, I went there to photograph once a week for the next five months.

It was a remarkable and terrifying scene. I saw buildings that had fallen over others like stacked dominoes, apartments listing like ships at an angle on piles of rubble. Some buildings were standing but missing entire

You spent many days looking at historical 1906 photographs in collections and archives before choosing certain images to rephotograph. How did you make your selections?

There was some preliminary on-site research at the Bancroft Library and later at the Legion of Honor and the Stephen Wirtz Gallery. But actually most of the research was done online, searching Web-based archives. Unfortunately, that's the reason some important collections weren't used for this project. If the work wasn't accessible online, I couldn't consider it. It cost money and time for us to be in the Bay Area, and since the expenses came out of pocket, it made more sense to do research at home and spend time on the ground doing photography. This approach was possible because there was no shortage of photographs online; in fact, there are thousands. The Online Archive of California [OAC] is a tremendous resource, and the images downloaded are good enough for printing and taking into the field for rephotography. It's the first time I've been able to work from images off the Web, and the process saved lots of money.

Did you select certain photographs because they were famous or because the sites were easy to locate? Did you have to be drawn into the photograph, be intrigued by it?

Most of the photographs weren't famous and in fact were taken by now-anonymous photographers. Even from home, before I knew what remained of 1906, it was clear that only certain subjects were the focus of a large majority of the photographs. So I began to group images based on subjects and locations—for example, images of the Call Building, Union Square, refugee camps, and so on. My standard technique is to overcol-

lect images, and this proved to be a good working method. The vast majority of photos culled from research were unusable for rephotography. This might have been because the subject no longer exists or the vantage point is now inside a building or a new building blocks the view. Many of the most interesting photographs fit this description. Of the remaining photographs, we revisited virtually all the subjects that were repeatable. After eliminating redundant photos, the work came down to about eighty-five sites. It's possible to do more, but time constraints for publishing the book and organizing the exhibition established an end point to the research and fieldwork.

One imagines that your decisions to choose certain vintage photographs to rephotograph are based on technical information regarding locations. But, based on your notions of rephotography, is there an intuition that certain photographs might yield more interesting comparisons than others?

I'm never sure what will be interesting as a comparison until we find the original vantage point. The result of this work is to create a pair of photographs, and that means that the two images are necessarily meant to modify each other. An interesting photograph as a starting point may actually become a liability when paired with a new image if there's no sense of relationship between the pictures, no synergy, so to speak. Likewise, an image that appears mediocre at first may change completely when paired with a new photograph. The pairings create a new context that often defies expectations about what are the most or least interesting images to repeat.

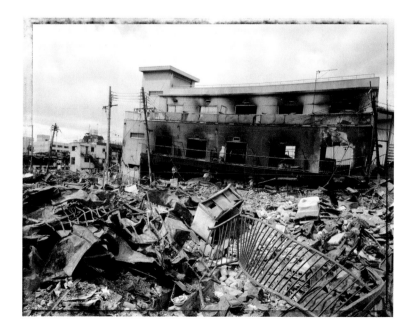

An apartment building destroyed by fire in Kobe, Japan, following the 1995 earthquake. (Mark Klett)

An example would be the image of the Kohl Building [plate 13B], which on its face is a perfectly undistinguished photograph of a surviving building from half a block away. People are seen walking toward the building and away from the camera. In the rephotograph [plate 13A], the building is almost obscured and dwarfed by the larger structures surrounding it in the Financial District; only a corner of the Kohl Building is visible. But now a line of taxis points in the same direction as the people who were walking in the original, and one taxi carries a placard that reads "This Way to Your Future." In the background, a poster of a woman's face appears on a light pole banner, the only human element that faces the camera. It's actually an image of Liz Taylor from a painting by Andy Warhol, advertising a show at the San Francisco Museum of Modern Art. These juxtapositions and their potential for larger connections are what interest me. But there's just no way to predict the result until one visits the scene.

How much did you think about the motivations of the photographers, known or unknown, who were photographing in 1906? How do they affect your rephotography? Did you read any journals, books, or newspaper articles in advance of shooting to find out more about them?

I read Philip Fradkin's manuscript for *The Great Earthquake and Firestorms of 1906* [published in 2005 by the University of California Press], and it provided an excellent foundation. But other than his description of the experiences of photographer Arnold Genthe, I knew little about the early photographers involved. This is a departure from the way I normally work in rephotography. The photographers are usually well known, and there's lots of historical material to sift through. But the 1906 photographers included a very large group of both professionals and amateurs, and they worked with different motivations. Don't forget, this is around the time that cameras became accessible to larger numbers of people. Some were photographing their experiences; others were making insurance records, creating souvenirs for sale, and so forth. So the resulting record was a real mix of disparate visions and purposes. But that's what made it interesting in a way—that it didn't boil down to just one or two singular views.

You mentioned that you were particularly drawn to Arnold Genthe's photographs in making your selections. What was it about his photographs that drew you to choose so many for rephotography?

He was the photographer who made the most coherent record of the disaster. He began working right after the earthquake and followed the event through the height of the fire and then to the ruins and, later, the refugee camps. Since he was a professional to begin with, the photographs are generally better made than the anonymous views. Unfortunately, many of his most interesting images simply can't be repeated for a project like this.

Interview with Karin Breuer

For example, he often photographed from inside charred ruins, a good idea from a visual perspective because it draws the viewer into the scene. But these vantage points are gone and obscured by new construction.

Genthe's photographs of San Francisco in the hours, days, and weeks after the earthquake are distinguished by their deliberate inclusion of people, in almost every shot and often as a device to frame or fix the subject. Did that impress you or lead you to want to make the same kinds of connections in your rephotography of his work?

The human connections to the disaster are one of the most important parts of Genthe's record. And it played to his strengths, since portraiture was his specialty. He worked in the aftermath of a disaster, when strangers forged common bonds by necessity. And I think the photos are fused with a kind of shared experience. Our times are different. People are usually present in many of today's scenes, and we sometimes waited to include them. But on the street, people move quickly, and there's little personal contact. The exceptions were street people, who congregated around us in some parts of the city. Working with a view camera is slow business, and staying in one place for long can invite trouble.

Our experiences on the street were far more agreeable than negative. There was some skepticism about our efforts, but it usually disappeared

as soon as we revealed our collection of historical photographs. We were trusted and given access to spaces we needed to make photographs every time we asked. This made me realize that San Franciscans love their city and still share a strong interest in its history. I felt that the work would matter to viewers, and that was an important motivation.

Ansel Adams called Genthe's earthquake photographs a "magnificent documentary recording" of the disaster, because of his "sensitive awareness" and special way of "seeing." Through your inspections of Genthe's photographs for the After the Ruins project, do you find that to be true?

Well, Genthe was perhaps the only photographer to make pictures that were both personal and articulate records of the disaster. I think you can tell when a photographer has a personal stake in the images, when an experience steers the vision. So I'd say they were more than documentary recordings. But something strongly felt also makes the records that much more powerful.

With many of your previous rephotographic survey projects, you have written about the technical problems and issues you faced. Can you describe some of those that were unique to San Francisco?

Working in a city poses logistical problems. Gaining access to vantage points can be difficult. Permission is needed to get on places like rooftops, to go inside office buildings, and so on. This takes phone calls and follow-up, knocking on doors, something that Philip, with his journalism experience, and his photographer son, Alex, are both really good at; they helped us a lot. Having guides like Rebecca Solnit who know the city so well and have connections to people with access to selected spaces was also instrumental. So while access was often the largest consideration in arranging the work, we also found advantages to being in a city once we were on the street. We were able to rephotograph as many as six sites a day because many were clustered together. This would be impossible in the Rocky Mountain West, where significant locations are separated by long distances.

Probably the biggest problem on a daily basis was repeating camera positions that were in the middle of streets. This happened often—for example, when we repeated Genthe's photograph of people watching the fire approach on Sacramento Street [plates 21A and 21B]. Genthe was using a hand-held camera and wasn't concerned about street traffic. But we had to stake out the same territory while dodging cars. Mike and I developed a technique. First we eyed the vantage point without a camera, stepping into the street during a traffic lull. Then we set up the tripod at the correct height and relative angle while still standing on the sidewalk. During an-

other lull, we moved the camera into the street and framed the view. We quickly marked the position of the tripod legs on the pavement with duct tape and moved back off the street with the camera. As opportunity arose, we moved back onto the street with the camera, ready to expose as many sheets of film as possible. We took advantage of red lights and sometimes the patience of drivers. It worked.

I have a question about vantage point. Not all of the rephotographs rely on using the exact location or an exact vantage point. What makes them successful when they don't?

Actually, all the rephotographs are made from as close to the original vantage point as we could determine. We did this by taking the copy prints of an original image to the site and lining up the subjects that still remain in a way that reflects the spatial geometry of the scene. There are specific methods for doing this, ones that involve taking measurements and comparing relationships between foreground and/or distant objects.

But the accuracy of the rephotography was by necessity more variable in this situation. That is, there are often fewer reference points from which to measure camera position, and these measurements are directly related to how accurately we can find original vantage points. Lack of data makes the work less technically accurate. Each rephotograph has a margin of error. In the city, where there's a lot of change, the position error might be as much as ten or twenty feet, whereas in a detailed landscape it might get down to a few inches. Most of the rephotos were closer to the originals than that, but in many ways having less data to measure made the work easier to do. Without detailed points of measurement, there's simply no way to tell whether the camera position should be, say, in one spot or in another three feet to the left. And that leaves room for making a judgment about which position offers the more interesting photograph while still being as accurate as the data allows. What I think makes a rephotograph successful is when viewers are convinced they are seeing the same place. That is less about technical accuracy than visual verification.

In some of the 1906 earthquake photographs, the landscape was changing even within days of when a photograph was taken. Fire and the dynamiting of buildings caused destruction beyond the obvious destruction of the quake. Did you take any photographs of locations that you knew were bound to change soon after you took them?

Only a few sites were in an obvious state of transition. An example would be the band shell in Golden Gate Park, temporarily fenced off by the construction at the de Young museum [plate 42A]. Otherwise, one might as-

sume a kind of continuity by looking at the contemporary scenes. However, one thing I learned from my previous work on the Muybridge panorama was that the city is in a constant state of metamorphosis. I recall making test shots for that panorama only to find, less than two months later, that a building in one panel had been demolished. In the urban environment, it's a given that the forces of change are always present. We can often predict the reasons for change, but what is unknown is the duration of change and whether or not we will be aware of it happening. For all we know, the city may change overnight if there's another earthquake. That's something we couldn't help but notice. But the gradual removal of buildings might go on for years before enough change has transpired to trigger a reaction in the casual observer.

You anticipated many of the challenges of photographing sites in a dense, urban environment. Did that expand your artistic vision with regard to rephotography?

I think so. For one thing, it's been a way of framing my other efforts. Common ties between projects have been the intersection of land, culture, and representation. So in retrospect it seemed overdue that an urban setting would enter into this equation. And I think our solutions here extend ideas of time and context for each view.

Would you consider taking on another city like San Francisco for a rephotography project?

Yes. But after three projects, I feel the same way I did twenty years ago after the RSP—that is, I am not in a hurry to do more of this work. Rephotography is actually a process as much as a result. It's a way of engaging history and discovering that old ideas are ripe for reworking into new forms. It's a way of getting on top of that old feeling that it's all been done before. On a personal level, the work has replenished the well of ideas and experiences that I tap into for new inspiration. So at this point I'd like to work through a few of the lessons from this project, and that might take a few years.

HELL ON EARTH | PHILIP L. FRADKIN

This nation's greatest urban disaster began when the footsteps of a frightened bather left luminous streaks on the sand of Ocean Beach, a shock wave fooled ships' captains into believing they had struck bottom off the Golden Gate, and a pulse of energy rolled swiftly down Washington Street in San Francisco, lifting urban structures and depositing them intact.

Such phenomena—seemingly magical—have been reported elsewhere in such divergent places as Japan and Southern California. Earthquake lights, sounds, and unusual movements have been documented anecdotally and constitute a seismic apocrypha. They are followed by a harsher type of reality.

A reasonable facsimile of hell broke loose in San Francisco on April 18, 1906, lasting for the next three terror-filled days and Walpurgis nights, as the more destructive seismic waves quickly followed and violent firestorms scoured the largest city west of the Mississippi River. Temperatures in excess of 2,000 degrees Fahrenheit melted glass, twisted steel, and sucked the life out of humans and animals alike. Tons of dynamite failed to halt the flames and instead acted as incendiary devices. It was the equivalent of an intensive, three-day bombing raid. At the end, three-fourths of San Francisco lay in ruins that were beyond stark. They were, quite literally, skeletal.

An even greater proportion of Santa Rosa, the center of Fort Bragg, and the heart of downtown San Jose were also shaken and scorched. A jagged scar in the earth marked most of the 270 miles of the San Andreas Fault that had fractured during the forty seconds of violent shaking. Rural communities from Shelter Cove in Humboldt County to Hollister in San Benito County sustained damage, mostly to poorly constructed brick and stone buildings. Most of Stanford University and nearby Agnews State Hospital in San Jose were gleaming new structures before the earthquake and mounds of bricks and stones afterward. More than one hundred mentally disturbed patients at Agnews Hospital, along with the medical staff who had cared for them, died in the rubble.

The Northern California earthquake would become the prototype for all natural disasters in the United States and the closest this nation has come to experiencing the massive numbers of deaths and extensive destruction associated with modern warfare. The flames that followed the earthquake destroyed an area six times greater than that ravaged by London's Great Fire of 1666. The death toll and the damage exceeded the losses incurred in the British sacking of Washington, D.C., in 1812 or Sherman's torching of Atlanta during the Civil War. The devastated area was twice as large as the swath of destruction cut by the 1871 Chicago fire. Even the terrorist attack on New York's World Trade Center in September 2001 did not approach the near obliteration of an entire American city.

San Francisco, stereotypically portrayed at the time as a gay, fun-loving city and now as a haven for the liberal-minded, became an icon of destruction—a fact whose denial began in earnest one hundred years ago and continues to this day. Then, as now, there had been forewarnings. Previous fires had destroyed the entire city during the gold rush years, and there had been damaging earthquakes in 1865 and 1868. "Earthquake and Fire—can you conceive engines of war more devastating! And yet we knew of the imminent danger from both. Knowing, we did nothing to protect ourselves from disaster," wrote a prominent merchant in one of the city's newspapers.

For eighty-three years, the city was relatively still. Had most San Franciscans not been hovering around television sets at 5:04 P.M. on a Tuesday in October of 1989 to watch the two local major league baseball teams play in the third game of the World Series, and had it not been a windless night, the moderate Loma Prieta earthquake would have been far more destructive than it actually was.

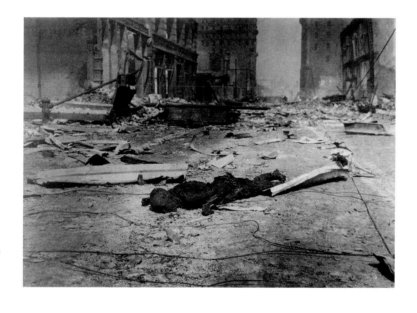

As seen in Genthe's 1906 photograph of a charred corpse, the intense heat of the firestorms caught fleeing victims in midstride.

In 1906, luck was also on the side of San Francisco. The magnitude 7.8 earthquake struck on a Wednesday at 5:12 A.M., when few people were on the streets. The epicenter was on the coast, near where the counties of San Francisco and San Mateo meet.

Within three hours and without a declaration of martial law, regular Army troops were on city streets, to be followed by the Navy, Marines, National Guard, and military cadets from the University of California. It was the longest and largest occupation of an American city by U.S. armed forces.

The military and a self-proclaimed ruling oligarchy commandeered the city. It was all very efficient—and quite illegal. Civil liberties evaporated instantly. The mayor issued an order not to arrest but to "KILL" anyone suspected of a crime (the emphasis was his). An undetermined number of poorer people and individuals from ethnic minority groups were shot.

Meanwhile, the fires grew in intensity and would eventually cause the greatest damage, although by itself the earthquake would have left substantial ruins. The sounds of warfare, heard in the cannonading of the dynamiters, and the sounds of flight, represented by the scraping of heavy trunks being dragged over stone streets, assaulted the senses along with the dense, mushrooming clouds of smoke.

A San Francisco woman, whose remarkable handwritten letter does not reveal her identity, left a dramatic account of what it was like to survive the firestorms:

A terrific tidal wave of fire had started somewhere down in the Valley and rushing outside I saw in the heavens what seemed a funnel shaped cloud enlarging until the size of a turn table, into this yawning black chasm, the flames seemed to leap a hundred feet into the air, one glance showed our section was doomed. A shout from a soldier that they were dynamiting our home, caused me to rush to the street and start for my pre-arranged place of safety. . . . All this time this terrific whirlwind was catching up big pieces of timber roofing, everything whirling through the air, & with difficulty one could walk, reaching the seawall I was hurried on I knew not where.

The woman took refuge behind some freight cars. They burst into flames. She ducked into a shed, only to watch the roof catch fire. A "liquid mass of flame" rolled toward her from the west. A cyclone carried tin roofs and ridge poles upward, as if they were merely soaring kites.

She climbed the steps to the top of Telegraph Hill, seeking safety. "Here were huddled hundreds of miserable people seemingly mostly the poorer classes. Pictures of despair and terror." The woman rested for a moment. The fire blocked escape toward the Western Addition. She walked southeast on Broadway, keeping to the middle of the hot pavement in order to avoid the flames on either side and dodging the dangling electric wires. She reached the ferry and made it to Berkeley that night.

The great disaster begat a great relief effort, beginning on Saturday. Sympathy for the victims was expressed in donated currency and goods from all across the land and from foreign countries too. The organization of the relief effort was authoritarian and rapid. Communities of tents, wooden barracks, and cottages were constructed near Fort Mason, in the Presidio, in Golden Gate Park, and elsewhere for the more than two hundred thousand homeless. Many preferred to erect temporary structures in smaller parks and their own neighborhoods. Raw food was distributed at first, and then camp kitchens and tables were set up to encourage the use of established facilities. Clothes, shoes, toys, tools, and other donated items of every description—not all of them usable—were dispersed or seized when needed. The citizens' relief committee distributed $9.2 million, of which $2.5 million came from Congress, intended to cover military expenses. The last official refugee camp was not closed until June 30, 1908.

As the city prepared to move on from its ordeal, San Franciscans' penchant for denial once again came to the fore. The singular purpose of the city's collective will was to reconstruct San Francisco as quickly as possible on the same vulnerable ground with a minimum amount of safeguards. The civic agenda of the following years emphasized public celebrations designed to send the message to the nation and the world that San Francisco was back, bigger and better and more beautiful than ever.

■

As they demand body counts in wars, Americans demand numbers to distinguish their major natural disasters. Such measurements are better perceived as general indicators than as precise amounts, since there is no way to accurately quantify such widespread death and destruction. The chaos sown in the wake of such a catastrophe is papered over by numbers.

Somewhere between three thousand and five thousand people died in 1906. Injuries were unusually light in comparison to the number of dead. About one thousand people were hospitalized, some four hundred with serious injuries. These figures do not include those who contracted such disaster-related diseases as typhoid, smallpox, and plague.

An area of 4.7 square miles—508 city blocks, 2,831 acres—was leveled by earthquake, fire, and dynamite. This expanse was roughly equivalent to 20 percent of the Borough of Manhattan. The fire front—the boundaries of the fire—extended for 9.3 miles, comparable to that of a major wildfire.

A total of 28,188 structures burned, 24,671 of them wooden. Forty-two of fifty-four so-called fireproof buildings were damaged extensively. Like a serpent whose hot breath exceeded its immediate grasp, the intense heat ignited the fires that devoured the interiors of these structures, leaving steel-framed skeletons in its path.

The loss of infrastructure was staggering, including a long list of ruined public buildings: the City Hall; the Hall of Justice; the Hall of Records; the county jail; five police stations; twenty-seven fire houses; three emergency hospitals; thirty-one schools, serving nearly forty thousand pupils; and the main public library as well as two branches and a number of specialized and private libraries. The new City Hall, the tall Spreckels Building (also known as the Call Building), and the grand Palace Hotel, all gaudy symbols of the city's wealth on the eve of the earthquake, were either totally destroyed or gutted.

The extent of damages cannot be accurately represented in today's dollars. We can calculate a figure that allows for inflation, but it would not take account of the huge increase in comparative values. The city's estimate of the total property loss in 1906 was $250 million, which did not include the value of the contents and furnishings of the ruined structures. No value was placed, for instance, on the tens of thousands of books lost in libraries or on the thirty million gallons of well-aged, premium wine that had been stored in San Francisco. A committee representing thirty-five insurance companies put the total loss, which it said "will probably never be actually known," at $1 billion. Approximately one-fifth of that amount was paid out in insurance claims.

Needless to say, an equivalent disaster today would mean many billions of dollars in losses and would set new records for destruction in this country. Consider the following scenario: on the basis of inflation alone, the loss of $1 billion in 1906 represents slightly over $20 billion today. Recent projected estimates of damages from a similar earthquake in the Bay Area today vary from $170 billion to $225 billion. Casualty estimates range from twenty-eight thousand to forty-five thousand deaths, with ninety thousand serious injuries.

■

After viewing more than ten thousand photographs in all the principal California earthquake archives, writing two books on California earthquakes, and personally having witnessed the urban riots of the 1960s, the Vietnam War, and numerous natural disasters in California, it is quite evident to me that while words provide context—that is, history—images convey the immediacy of violent horrors far more effectively.

The problem is that the unimaginable vastness of such images, such as the aerial photographs of Hiroshima and ruined San Francisco, dulls the mind after a few minutes. A stroll to the edge of the Grand Canyon does

Philip L. Fradkin

the same to me. In contrast, many times a detail, such as the human shadow burned into the pavement of the Japanese city, can be more telling. The mind and emotions are jarred by a metaphorical slice of the whole.

Images also authenticate. "In the modern way of knowing," as Susan Sontag wrote of wars and natural disasters in the age of television, "there have to be images for something to become 'real.' Photographs identify events. Photographs confer importance on events and make them memorable."

The San Francisco earthquake and fire made photographic history. The first cheap cameras and roll film had just come on the market. "Snapshots," a word derived from the vocabulary of the hunter, were now possible. A post-quake article in *Camera Craft,* the monthly publication of the California Camera Club, noted: "The probabilities are that never since cameras were first invented has there been such a large number in use at any one place as there has been in San Francisco since the 18th of last April. Everyone who either possessed, could buy, or borrow one, and was then fortunate enough to secure supplies for it, made more or less good use of his knowledge of photography."

Amateurs, much to the disdain of professionals, whose dominance of the craft was being challenged, had invaded the field of photography in huge numbers since the advent of smaller hand-held cameras, faster lenses, speedier film, and the increased ease of processing and printing. Kodak led the way with the motto, "You press the button, we do the rest."

The author of a March 1906 article in *Camera Craft* extolled the virtues of his 3-A Folding Pocket Kodak:

The Kodak's popularity is demonstrated by the frequency with which we see it used. Its compact and inconspicuous form, the ease with which it can be carried and operated, coupled with the almost certain degree of success which is assured in the improved form, render it well nigh impossible for one to resist its allurements.

There were, however, a few drawbacks:

It is true that the lens will not work at a speed that will allow of photography under the more unfavorable conditions of light. Such conditions are occasionally present. The shutter is not fast enough to take trains moving at a rapid rate, but only the specialist finds more than a few subjects requiring this high speed.

Compared to the older 4 x 5 format, the more oblong shape of the new negatives made for more pleasing scenic shots, with the result being closer to the shape of a postcard. The film was also more forgiving, in terms of both initial exposure and processing. "My own companionable camera," wrote A. E. Suppiger one month before the earthquake, "has never taxed either my knowledge of photography or my purse to an extent at all in proportion to the pleasure which it has afforded."

The California Camera Club in San Francisco, whose membership included such professionals as Arnold Genthe, was one of the largest such organizations in the world. The comparative wealth of its citizens and the tremendous variety of photogenic landscapes made the state's largest city an obvious mecca for photographers.

At the same time as the revolution in equipment was taking place and more people were becoming picture takers, the halftone process was developed, making it possible for newspapers, magazines, and books to carry photographs on the same pages as text. Taking advantage of this new technology, mass photojournalism was born during the San Francisco catastrophe. A pioneer in the use of photojournalism, media baron William Randolph Hearst hurried from his home in New York to his native San Francisco to direct coverage of the disaster and to play a major role in the relief efforts.

As the earth shook and flames erupted, local camera owners were confronted with the classic range of decisions facing recorders of major disasters: whether to document events, take care of personal needs, or flee the immediate scene. The decisions were not clear cut; the options could, and did, overlap. Other photographers from outside the area flocked to San Francisco, arriving from Oakland, from elsewhere in California, and from other states.

All those who attempted to photograph the cataclysm faced unusual obstacles. Simply getting into San Francisco during the three days was extremely difficult, as passes were required. Finding food, water, film, and a safe place to sleep required diligence. As photos were taken, dangling electrical wires had to be avoided, both for aesthetic purposes and personal safety.

Technical problems abounded. Smoke and blowing ash darkened and obscured scenes beyond the ability of cameras and film to capture them. The high winds generated by the firestorms knocked over cameras mounted on tripods. The wooden legs of the tripods caught fire from the intense heat. With people fleeing in large numbers, time exposures were not practical. There was a shortage of developing chemicals.

For those motivated by commercial gain, the window of opportunity was narrow; dramatic photographs of the stark ruins would be impossible once the rebuilding process began. One photographer lamented: "Instead of beholding one of the mighty tragedies of history, we shall soon be spectators at a common-place, every-day drama."

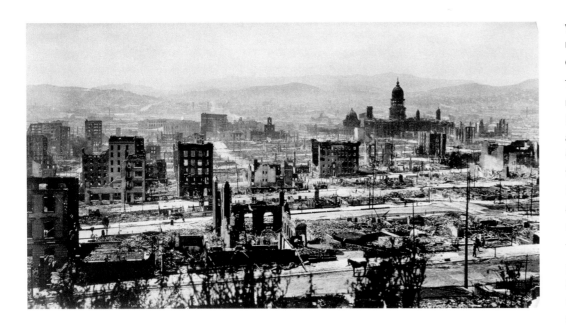

Looking south from Nob Hill, with the old City Hall on the right, Arnold Genthe photographed the ruins of the city in 1906.

Some photographers made considerable amounts of money. The photos that commanded the most sales depicted buildings that spouted smoke and flames. Prints were sold singly, in packets, as hand-tinted postcards, doubled to fit stereopticons, and in virtually any form that could serve as a profitable souvenir, including a number of quickie books. One professional made 250 exposures in ten days. He sold several thousand prints to customers east of California.

Venality was not unknown among the photographers, just as price gouging was not uncommon among merchants. If one photographer had a superior print, others sometimes attempted to obtain it, copy the image, and sell it as an original. *Camera Craft* noted: "It is common talk that much copying of other people's work has been done for commercial purposes. One gentleman who has some very fine fire effects had to send a lawyer to a prominent gallery to compel them to stop selling copies of his pictures."

Some photographers simply chose not to take pictures. Not all camera owners were committed photographers. Others thought it was indecent to record or make money off the misfortunes of their fellow citizens. A few were entranced by the aesthetics of disaster and chose to watch without a viewfinder coming between them and the colors that could not yet be captured on film. Of the City Hall's collapse in the earthquake, one cameraless photographer said: "But few subjects would offer a more dramatic field for a great artist than the wreck of that mighty building standing in its

yellow cloud of dust against the tender blue of the spring day." But for most, the needs of family, relatives, friends, and self came first, and many chose to escape the burning city.

The photographers who remained and made superior images deserve mention. They include the anonymous photographers who worked for the Bear Photo Company, Stewart & Rogers, and the Padilla Brothers as well as such individuals as Louis J. Stellman, Willard E. Worden, and Arnold Genthe. The range of their work represented the split in photography at the time—art, or pictorialism, versus accurate documentation, with the latter predominating because of the nature of the event. The pillars of ruins attracted the pictorialists such as Genthe, who suddenly found scenes reminiscent of ancient Greece to photograph in California.

The rural areas were not neglected. Jack London used a Kodak camera proficiently when he toured the damaged towns and settlements in Sonoma, Napa, Lake, and Mendocino Counties on horseback with his wife, Charmian. For the 650-page State Earthquake Investigation Commission report, geologist Andrew C. Lawson of the University of California dispatched scientists with cameras who, besides documenting damage along the fault line, inadvertently provided the first photographic baseline study of California from the forests of Humboldt County to the deserts of San Bernardino County.

In the Bay Area, it soon became apparent that overall shots from such prominent heights as Nob Hill could not encompass the whole sweep of the destruction. Meeting the challenge in that flightless era required daring and innovation. Harry J. Coleman of the *San Francisco Examiner,* a Hearst newspaper, precariously ascended the skeletal framework of the wrecked City Hall cupola. The resulting photographs were only partially successful; greater height was needed. The *Examiner* ran a "Balloons Wanted" ad, and a Petaluma showman responded with a rickety device. The balloon, with Coleman on board, rose and then sank slowly to the ground.

George R. Lawrence of Chicago was more successful with his custom-made wood and aluminum camera mounted at the end of a linked train of seventeen kites. The shutter was tripped by an electrical current that ran through a wire to the forty-nine-pound camera, which took dramatic panorama photographs from between six hundred and two thousand feet above the city and the bay. The *Examiner* and Lawrence profited from the souvenir supplements that ran in the newspaper and the prints that were sold for $125 apiece.

The Army Signal Corps also experimented, sending aloft balloons and kites with dangling cameras. From techniques developed in 1906 came the unmanned aerial reconnaissance efforts of World War I.

San Francisco photographers, including a child who would soon join their ranks, found both humor and despair in the aftermath. Ansel Adams, who would later reprint some of Genthe's work on the fiftieth anniversary of the earthquake, was four years old at the time and living with his family in the sand dunes of the Western Addition. He later recalled: "It was fun for me, but not for anyone else. I was exploring in the garden when my mother called me to breakfast and I came trotting. At the moment a severe aftershock hit and threw me off balance. I tumbled against a low brick garden wall, my nose making violent contact with quite a bloody effect. The nosebleed stopped after an hour, but my beauty was marred forever—the septum was thoroughly broken."

Many San Franciscans, such as the portrait photographers Adelaide Hanscom and Arnold Genthe, lost their personal possessions and their work. Some photographers and photo shop owners were reimbursed at least partially by a fund set up by other photo enthusiasts. Fortunately, Genthe, who remained in the city and documented the destruction with a borrowed 3-A Kodak, had earlier stored his Chinatown negatives in Carmel at the insistence of a friend who thought the city was ripe for fire.

The socially connected Genthe was the best-known photographer in San Francisco at the time. Highly educated in European schools, he had arrived in the city eleven years before the earthquake and would depart for New York four years afterward. On the night before the earthquake, Genthe had attended the social event of the year, a performance of the opera *Carmen* at the Grand Opera House, with the tenor Enrico Caruso in the role of Don José. The photographer was mentioned in the society column of a newspaper published that night (but never circulated very extensively on the morning of April 18) as having been seen chatting with a prominent judge. "They seemed very happy and like many Judges, may reserve their decision" on the opera, noted the reporter with a vain stab at wit.

It was Genthe who spied Caruso the next morning amidst the many trunks of the Metropolitan Opera Company in Union Square. With a fur coat over his pajamas and smoking a cigarette, the singer was muttering: "'Ell of a place. I never come back here." And he never did.

The next mention of Genthe in the society columns was on April 30, when he was spied by a reporter looking "cheerful under the circumstances" and "prepared to commence all over again." He was staying with friends outside the fire zone, had lost everything, and was taking "some excellent photographs of our poor distracted-looking city."

Genthe wrote in his autobiography of the shock and numbness that can lead to questionable decisions:

I know from my own experience that it was many weeks before I could feel sure that my mind reacted and functioned in a normal manner. If I had shown any sense, I might easily have saved some of the things I valued most—family papers, letters and photographs of my parents and brothers, books written by my closest relatives, and of course my more important negatives, which I could have carried away in a suitcase. As it was, practically everything I possessed had gone up in smoke.

But if Genthe and other photographers had made different choices, we might not have their photographs today—and Mark Klett's rephotographs—to learn from one hundred years later.

Notes

"Earthquake and Fire...": Raphael Weil, *San Francisco Call,* August 5, 1906.

"A terrific tidal wave of fire...": This woman's account is contained in the Hooker Family papers in the Bancroft Library, University of California, Berkeley. The handwritten word "Eleanor?" appears on its cover page.

"In the modern way of knowing...": Susan Sontag, "On Photography (The Short Course)," *Los Angeles Times Book Review,* July 27, 2003.

The March, May, and June 1906 issues of *Camera Craft* magazine, the publication of the California Camera Club in San Francisco, discuss the benefits of the new small cameras and the perils of photographing the catastrophe.

"It was fun for me...": Ansel Adams, *Ansel Adams: An Autobiography* (Boston: Little, Brown, 1985), 6–8.

"They seemed very happy...": "Strollers in Foyer Discuss New 'Carmen,'" *San Francisco Call,* April 18, 1906.

"cheerful under the circumstances...": "What Society Is Doing," *San Francisco Examiner,* April 30, 1906.

Arnold Genthe's account of the disaster is contained in his autobiography, *As I Remember* (New York: Reynal and Hitchcock, 1936), 89–97.

THE RUINS OF MEMORY | REBECCA SOLNIT

The Negative Image of History

The panoramic photographs taken after the 1906 earthquake show that the old city is gone, replaced by jagged, smoldering spires and piles of ruins. The photographs made a century later demonstrate that the ruins are likewise gone, erased more definitively than the earthquake erased the nineteenth-century city. Ruins represent the physical decay of what preceded them, but their removal erases meaning and memory. Ruins are monuments, but while intentional monuments articulate desire for permanence, even immortality, ruins memorialize the fleeting nature of all things and the limited powers of humankind. "Decay can be halted, but only briefly, and then it resumes. It is the negative image of history," wrote landscape historian J. B. Jackson. It is the negative image of history and a necessary aspect of it. To erase decay or consciousness of decay, decline, entropy, and ruin is to erase the understanding of the unfolding relation between all things, of darkness to light, of age to youth, of fall to rise. Rise and fall go together; they presume each other.

In another sense, everything is the ruin of what came before. A table is the ruin of a tree, as is the paper you hold in your hands; a carved figure is the ruin of the block from which it emerged, a block whose removal scarred the mountainside from which it was hacked; and anything made of metal requires earth upheaval and ore extraction on a scale of extraordinary disproportion to the resultant product. To imagine the metamorphoses that are life on earth at its grandest scale is to imagine both creation and destruction, and to imagine them together is to see their kinship in the common ground of change, abrupt and gradual, beautiful and disastrous, to see the generative richness of ruins and the ruinous nature of all change. "The child is father to the man," declared Wordsworth, but the man is also the ruin of the child, as much as the butterfly is the ruin of the caterpillar. Corpses feed flowers; flowers eat corpses. San Francisco

has been ruined again and again, only most spectacularly in 1906, and those ruins too have been erased and forgotten and repeated and erased again.

A city—any city, every city—is the eradication, even the ruin, of the landscape from which it rose. In its fall, that original landscape sometimes triumphs. One day, I looked up from an intersection in San Francisco's densely urban Mission District and saw to the south the undomesticated crest of Bernal Heights, with its coyote and wild blackberries, and to the west the ridgeline of Twin Peaks and with a shudder perceived, still present as a phantom, the steep natural landscape that underlay the city, the flesh beneath the clothes, the landscape that reappeared amid the miles of ruins of the 1906 earthquake and that someday will reassert itself again. Another day, I walked down Hayes Street west of City Hall and saw suddenly the surprising view of Bernal Hill across half the distance of the city, a vista opened up by the belated removal of the freeway overpass damaged by the 1989 earthquake. Some months before, I had watched the wrecking ball smash that overpass into chunks of rebar-threaded concrete small enough to truck away. The concrete mined from some place out of sight was being sent back over the horizon. A place like San Francisco could be imagined not as one city stretching out since 1846 but dozens of cities laid over each other's ruins, the way that archaeologists experience the unearthed ruins layered in strata, the several cities that lay above Homer's Troy. Dolls, whiskey and medicine bottles, buttons, sometimes ships and skeletons reappear along with the sand whenever a new foundation is dug in central San Francisco.

To make this city, much of a windswept, fog-shrouded expanse of sand dunes and chaparral-covered hillsides was smoothed over, dunes removed, hilltops flattened, bays and marshes filled in, streams forced underground, endemic species driven into extinction. Even the view of the resultant simplified topography was obscured by the buildings every-

where, though one of San Francisco's charms is its still-surviving steepness: the crests and heights offer views of the distance—not only the rest of the city, but the sea, bay, and hills beyond it. Another is the pure geometry of its grid, often criticized for being an overly two-dimensional response to a wildly three-dimensional terrain, but these straight axes also open up the distance visible at the end of the long shafts of streets. San Francisco is the least claustrophobic of cities. Both big earthquakes of the twentieth century shook the place loose of its bonds—the carpet of architecture in 1906, the ugly shackles of the Embarcadero and Central freeways in 1989.

In natural disasters, the natural landscape reasserts itself and reappears, not only as force but also as the contours beneath the cityscape. Cities are always maintained, for natural processes of decay produce ruins as surely as violence and fire, flood and earthquake do; and only maintenance and replacement postpone the inevitable ruin—the entropy of the built and the return of the organic. In his *Arcades Project* notes, Walter Benjamin quoted a Victor Hugo poem:

I think I see a Gothic roof start laughing
When, from its ancient frieze,
Time removes a stone and puts in a nest.

Stone to nest may be the death of a piece of architecture, but it is also a coming to life. Cities are a constant assertion against the anarchic forces of nature, and a disaster like an earthquake is the opposite, nature's assertion against the built world. San Francisco is the ruin of a lonely, untrammeled landscape, its buildings the ruin of forests, stony landscapes, gypsum deposits, veins of iron deep in the earth—and after 1906 all these sources were raided again, with urgency and intensity. A few trees were snapped by the earthquake, but forests were laid low for the hasty rebuilding of San Francisco.

The catastrophe of earthquakes is largely the catastrophe of built structures. Trees fall down or snap or split only in the most extreme earthquakes (as a few did here and there from the Santa Cruz Mountains to the Sonoma coast in 1906); under the open sky, creatures may lose their balance, but they are not crushed. Large earthquakes can also split open the ground and dam and redirect streams, but these are not catastrophic effects. No cow really fell into any crack, despite the popular mythology of '06. Before the Franciscans brought adobe architecture and the gold rush brought more massive development, the Bay Area's Ohlone and Miwok and other indigenous Californians likely regarded earthquakes with wonder but suffered little physical damage. Any lightweight structures that fell down could easily be rebuilt, and little damage to life would result from such a collapse.

Architecture is an earthquake's principal victim, architecture and infrastructure and anything alive that is in their way when they come down. Crumbling freeway overpasses and other structures built on soggy land are among the major wreckage of recent California quakes—witness the collapse of the Nimitz Freeway over bay landfill in Oakland and of apartments in the infilled Marina District of San Francisco in 1989, or of Los Angeles's Santa Monica Freeway above La Cienega (which means *the swamp* in Spanish) in the 1994 Northridge quake. These are victims, as a recent book by David Ulin has it, of "the myth of solid ground." Still, the ruins and tragedies in California are dwarfed by quakes of comparable size in other parts of the world—Mexico, Turkey, China, Iran, Algeria—where old and poorly built structures have crushed citizens by the thousands.

Man proposes, earthquake disposes, the maxim might be revised to say, though earthquakes are only one small source of the ruins that are in some ways the inevitable corollary of the very act of building. That nothing lasts forever is perhaps our favorite thing to forget. And forgetting is the ruin of memory, its collapse, decay, shattering, and eventual fading away

into nothingness. In the 1860s and 1870s, Eadweard Muybridge photographed San Francisco buildings rising over time: the San Francisco Mint (which survived 1906) and the Appraisers' Building (which did not). These images, taken from a more or less stable vantage point, seem like precursors of Muybridge's more famous motion studies: rather than showing the few seconds of time that pass while, for example, an athlete turns a backward somersault in midair, they show the months over which a construction site becomes a completed building. They anticipate time-lapse photography, in which flowers bloom in seconds, seasons change in minutes.

But these sequences don't defy our senses as Mark Klett's rephotographs of the 1906 earthquake do, for we understand that buildings arise from piles of material and scaffolds and foundations. We don't quite recognize how resilient cities are, how they arise over and over again from their own ruins, resurrected, reincarnated, though every Rome and London is such a resurrection, or reinvention. So it seems strange to see the ruins of then become the smooth façades of now, to see not the entropy that leads to ruin but the endeavor that effaces it so thoroughly that its ruinous past is hardly believable. Yet this happens again and again: Frank Gohlke's 1979–1980 photographs of the Wichita Falls, Texas, tornado show a place torn apart by wind and the same place a year later, restored as though nothing had happened (or so that the same thing can happen again?). Ruins are evidence not only that cities can be destroyed but that they survive their own destruction, are resurrected again and again.

Ruins stand as reminders. Memory is always incomplete, always imperfect, always falling into ruin; but material ruins themselves, like other traces, are treasures: our links to what came before, our guide to situating ourselves in a landscape of time. To erase the ruins is to erase the visible public triggers of memory; a city without ruins and traces of age is like a mind without memories. Such erasure is the foundation of the amnesiac landscape that is the United States. Because the United States is in many ways a country without a past, it seems, at first imagining, to be a country without ruins. But it is rich in ruins, though not always as imagined, for it is without a past only in the sense that it does not own its past, or own up to it. It does not remember officially and in its media and mainstream, though many subsets of Americans remember passionately.

The Pueblo people of New Mexico remember the conquistadors, and Native Americans generally remember the genocides and injustices that transformed their numbers and their place on this continent. Southerners remember the Civil War; African Americans remember slavery and Jim Crow; labor remembers its struggle for the right to organize and a living wage; too few women remember the battle to get the vote and basic human rights. Memory is often the spoils of the defeated, and amnesia

may sometimes be the price of victory (though Germany in its postwar era proved that the vanquished can erase even more vehemently—but most vanquished can think of themselves as wronged, and being wronged is all too fine a foundation for identity).

Much of the North American continent is the ruin of intact ecosystems and indigenous nations, absences only history and its scant relics recall, for most of this ruin consists of absence: the absence of bison, the disappearance of passenger pigeons, the reduction of the first nations to reservation dwellers and invisible populations. These nations built lightly and out of organic materials, more often than not, so their own ruins are faint, except perhaps for the great mounds of the Midwest and the stone architecture of the Southwest, Mesa Verde, Chaco Canyon, and the other Anasazi/Pueblo ruins. The Southwest's ruins are considerable, and even its mesas and buttes were often interpreted as resembling the architectural ruins of medieval Europe—or, rather, of romanticism's taste for medieval Europe.

Manhattan is a city founded in the seventeenth century, but it is hard to find traces of the city earlier than the nineteenth century there. Santa Fe is older, and it too contains little that predates the past couple of centuries. But Paris, famously ripped up and redeveloped in the third quarter of the nineteenth century, is still full of buildings from the twelfth to the eighteenth centuries. Peru has Machu Picchu, the ruins of a Quechua city. Guatemala has Antigua, the former capital largely abandoned after the great earthquake of 1773—now a small city or large town, its colonial grid intact and ruins of splendid baroque convents and churches standing in between the one- and two-story houses—along with Tikal, the Mayan city abandoned long before and visible only because the devouring jungle was pared back some decades ago. Mexico has the ruins of the Aztecs. The United States is curiously devoid of acknowledged and easily recognized ruins. Perhaps some of the amnesia is the result of mobility; people who are constantly moving are constantly arriving in landscapes that do not hold their past and thereby are often read as not holding a past. History is opaque to the deracinated, and enough moves can obliterate both history and the knowledge that every place has a history. (I have learned in my own San Francisco neighborhood that people who move every few years believe they move through a static cityscape; those of us who sit still for longer periods know it undergoes radical transformations.)

Think of ruin in two stages. One is the force—neglect or abandonment, human violence, natural disaster—that transforms buildings into ruins. Ruins can be created slowly or suddenly, and they can survive indefinitely or be cleared away. The second stage of ruin is the abandonment or the

appreciation that allows the ruin to remain as a relic—as evidence, as a place apart, outside economies and utilitarian purposes, the physical site that corresponds to room in the culture or imagination for what came before. The forces that create ruin have been plentiful in the United States, but the desire or neglect that allows them to stay has been mostly absent. The great urban ruins have been situated on what is, first of all, real estate, not sacred ground or historical site; and real estate is constantly turned over for profit, whereas a ruin is a site that has fallen out of the financial dealings of a city (unless it has become a tourist site, like the Roman Colosseum).

Poverty, Lucy Lippard once remarked, is a great preserver of history. From New England through the Rust Belt, the poverty of lost jobs and defunct industry has left behind a ruinous landscape of abandoned factories and city centers, as has white flight and urban disinvestment in cities such as Detroit. We detonate our failed modernist housing projects, along with outdated Las Vegas casinos, as though we were striking sets; demolition telescopes the process of ruin from damage to disappearance. Only in the remote places—the abandoned boomtowns of nineteenth-century mining rushes, old plantation mansions, the withering small towns of the Great Plains—is nature allowed to proceed with its program of ruin. And in the destitute ones: descriptions of a ruinous and half-abandoned inner-city Detroit suggest that it is becoming our Pompeii, or perhaps our Antigua, destroyed not by earthquake or lava but by racially driven economic abandonment and its side effects.

The bunkers, batteries and other military infrastructure in the Marin Headlands, just north of the Golden Gate, are, with similar structures in the San Francisco Presidio, the most prominent surviving ruins in the area. (Mark Klett)

This is the paradox of ruins: they represent a kind of destruction, but they themselves can be destroyed and with them the memory of what was once there and what it confronted. Munich and Cologne in Germany, Birmingham and Coventry in England, and many other European cities keep traces of their wartime ruin on hand as reminders of not only the past but the present insecurity and uncertainty of all things, the architectural equivalent of vanitas paintings, those *ubi sunt* and *sic transit gloria mundi* statements. Hiroshima's Peace Dome is a well-known monument to the atomic bomb dropped on that city, a monument with far more meaning than the building had before the bomb, when it was the Prefectural Industrial Promotion Hall.

In the haste to remove the hundreds of thousands of tons of wreckage of New York's World Trade Center buildings and replace them with a newly made monument, one can see a deep anxiety about what ruins commemorate: ephemerality, vulnerability, and mutability. The singular urbanist and ex–New Yorker Jane Jacobs commented that we don't know what the disaster means yet and that it is too soon to build something; the instant memorial seems part of the therapeutic language of "closure" that was deployed again and again in the immediate aftermath of the towers' collapse, a word that seemed to mean that meaning itself could come to an end, a conclusion. Ruins are open to the eye, the sky, the elements, change, and interpretation.

When the World Trade Center fell on September 11, 2001, a kind of American innocence, a widespread belief in American impunity, fell with it. This belief was itself shocking, premised as it was on the notion that we were somehow beyond the reach of the forces, natural and political, that devastate other countries, situated in an ignorance or inability to identify with the victims of death squads, genocides, wars, industrial disasters; with the inhabitants of Bhopal, Chernobyl, Guatemala, Rwanda, Iraq. This belief was rooted not only in American exceptionalism but in amnesia—about the swath of devastation Sherman left across the Civil War South; about the devastation of Galveston, Charleston, Chicago, and other major cities by natural forces; about the essential vulnerability of individuals and communities; about mortality itself; and perhaps about the devastation the United States has wrought elsewhere (and for that September attack, Kabul and Baghdad were ravaged on a far grander scale with far more deaths, many eyes for an eye, in devastations that again seemed unfelt and unimagined for many in whose name they were carried out). There is always an implication in American discourses on death and illness that they are optional, that the cure for cancer or heart disease is in some way a cure for death. As a hospice worker once told me, in this country we regard death as failure. Of course, some Americans remember lynchings and massacres, but they are not the mainstream or the "us" to whom the media speak.

But death is as inevitable to life as ruins are to buildings, and the death of individuals is not the death of communities. The 2002 movie *Gangs of New York* contains a small commentary on this in its closing frames. Two characters look across the water at southern Manhattan afire in the draft riots of the 1860s, and a dissolve turns the skyline into the pre-9/11 view dominated by the Trade Towers. This, too, these last frames seem to say, shall pass; we shall rise again, as New York has from the far more pervasive devastation of the 1970s and 1980s. Of these destructions, only photographs stand as memorials now.

Portals of the Past.
LEFT: **A pre-earthquake view of the Towne Mansion on California Street, ca. 1905 (detail).** MIDDLE: **A view of the devastated city framed between the remaining portals of Towne Mansion on Nob Hill, 1906 (Arnold Genthe).** RIGHT: **Portico of the Towne Mansion, moved to Golden Gate Park, 2003 (detail; Mark Klett with Michael Lundgren).**

San Francisco evicted even the dead from its land in the first half of the twentieth century (only a small military cemetery, an even smaller Spanish missionary church cemetery, and the Richmond District Columbarium of cremated remains survive). This was done essentially for economic reasons, but the effect was to eliminate death from the scene along with the dead, those who had inhabited the earlier versions of the city. Of the San Francisco earthquake, no clear evidence exists, only absences: the lack of nineteenth-century buildings throughout most of the city (though in 1906 the southern and western edges were still undeveloped). A number of landmark structures survived the earthquake and fire and were rebuilt, often almost into unrecognizability. One of the pleasures, or shocks, of looking at Mark's photographs is seeing the dowdy downtown Market Street buildings in ruins from which they have recovered without a trace.

But of 1906 ruins as ruins, nothing survives except the "Portals of the Past," the neoclassical portico from a ruined Nob Hill mansion that was transported to Golden Gate Park, where it looks more like a stage set than a relic, for it now frames foliage whereas once it framed a mansion's entryway and then the smoldering wreck of the city beyond where the mansion stood. Before and after the 1906 earthquake, the portals framed no vista, opened onto no long view: it is as though only for that moment of disaster was another vision, a more far-seeing sense of place and time, opened up; and the haste to reconstruct was in part haste to close that vision. Perhaps that vision is the view that all ruins offer us.

Ironically, it was earthquake rubble that became the ground of the Marina District, so devastated in 1989; landfill liquefies in an earthquake, which is why the downtown and Mission Bay buildings rest on massive pilings

driven below the landfill layers. Mission Bay was once a bay into which Mission Creek drained after its meander from near Mission Dolores. That bay was filled in to build the central railyard of the Southern Pacific Railroad, the great octopus that held all California's politics and economy in its tentacles, and it fell into ruin when the age of the railroads came to an end. The ruins made the place haunted and abandoned—for "abandoned" is our term for places inhabited by outcasts and wildlife—an open space in the most densely populated U.S. city outside New York. "Dream" said the graffiti on an old boxcar, and it was a kind of dreamspace, open to memory, possibility, danger, outside the economy, as ruins almost always are. These ruins were destroyed to build the Mission Bay biotechnology facilities at the end of the twentieth century. The railroads tamed the earth on one colossal scale; the biotech industry seeks to do so on another more intimate one; and the one thing certain is that the labs atop the landfill will lie in ruins someday, by earthquake or by time itself. Perhaps even the buried bay will reappear, carved out again when Mission Creek reasserts itself and rises from its subterranean passages.

The First Ten Destructions of San Francisco

San Francisco was in its infancy during the fire on Christmas Eve 1848, which destroyed more than a million dollars' worth of property (at 1848 values) and burned down most of the buildings around Portsmouth Square, then the central plaza of the rough little boomtown risen from the gold rush. The authors of the *Annals of San Francisco* described the situation:

This was the first of the great fires which devastated San Francisco; and it was speedily to be followed by still more extensive and disastrous occurrences of a similar character. Something of the kind had long been anticipated by those who considered the light, combustible materials of which the whole town was constructed. . . . Scarcely were the ashes cold when preparations were made to erect new buildings on the old sites; and in several cases within a few days, and in all, within a few weeks, the place was covered as densely as before with houses of every kind. These, like those that had just been destroyed, and like nearly all around, were chiefly composed of wood and canvas, and presented fresh fuel to the great coming conflagrations.

After this First Great Fire of San Francisco, five more would follow in the subsequent three and a half years, with the sixth erupting on the summer solstice, June 22, 1851. The third, the *Annals* recorded, destroyed five million dollars' worth of property.

But in proportion to the unusual depression was the almost immediate reaction, and the ruined citizens began forthwith to lay the foundations of new fortunes instead of those so cruelly destroyed. . . . As the spider, whose web is again and again destroyed, will continue to spark new ones while an atom of material or a spark of life remains in its body, so did the inhabitants set themselves industriously to work to rear new houses and a new town. . . . From this time forward, we therefore began to notice, that the street architecture gradually assumed a newer and grander appearance.

It also assumed a more fireproof appearance, as brick replaced wood, though brick was a far worse material in earthquakes.

By 1850, the writers could say of a fire damaging about a million dollars' worth of property, "Elsewhere such a fire might well be called a great one; but it was not so reckoned in the 'Annals of San Francisco.' " The fifth fire was the largest of all, coming after eight months of "comparative immunity from conflagration." This arson fire began on the night of May 3, 1851, on the south side of Portsmouth Square. It created a firestorm, burning between fifteen hundred and two thousand structures, most of the central city. Then the rebuilding began. ("Sour, pseudo-religious folk on the shores of the Atlantic, might mutter of Sodom and Gomorrah, and prate the idlest nonsense," said the *Annals* writers, asserting that the catastrophe was no punishment and that there was no reason why the city should not rise again.)

The sixth great fire came about six weeks after the fifth one. These six fires "successively destroyed nearly all the old buildings and land-marks of Yerba Buena," the original hamlet overtaken by the Yankees. There's a saying to the effect that "this was my grandfather's ax, though it's had four new handles and three heads since his time," the idea being that the continuity of use and of tradition is more powerful than the incessant replacement of materials. Something similar could be said of cities, except when memory is swept away with the masonry rubble. Memory is what makes it my grandfather's ax rather than some worn-out piece of detritus; memory is meaning.

The seventh destruction of San Francisco was the great and oft-forgotten earthquake of October 21, 1868, a rupture on the Hayward Fault estimated at 7.0 on the Richter scale. Five people died, spires and chimneys fell, walls tumbled, some brick buildings collapsed entirely, cracks opened up in the ground, the Custom House was damaged, and City Hall was devastated. And the city was rebuilt, with little regard for the *San Francisco Morning Call*'s editorial warning against shoddy construction, the use of cornices and other ornaments that could fall in a quake, building on landfill, and other seismically precarious practices: "The lives lost yesterday are not chargeable to the earthquake, but to the vanity, greed and mean-

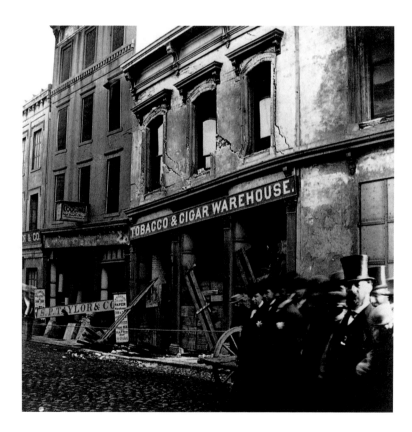

Eadweard Muybridge photographed the damage on Clay Street, in San Francisco, following the earthquake of October 21, 1868.

ness of those who erected the buildings." When San Francisco was largely destroyed by the 1906 earthquake and fire, the sixty-year-old city had already survived a series of destructions and rebuildings. After 1906—the city's seventh fire and eighth destruction—the destructions would be about social forces out of control rather than natural ones.

At one o'clock in the morning on July 27, 1943, the British Air Force, with support from the U.S. Army, began bombing the city of Hamburg. "The aim of Operation Gomorrah, as it was called," writes W. G. Sebald, "was to destroy the city and reduce it as completely as possible to ashes." In this, it was eminently successful, and thousands died. On the eve of Valentine's Day 1945, the same forces began dropping nearly four thousand tons of bombs on the city of Dresden, best known for its manufacture of china dishes, though it also produced gun sights, plane parts, and gas masks. Sixteen hundred acres of the central city, more than twenty-four thousand buildings, and somewhere between thirty and one hundred thousand people were destroyed in the firestorm, the fire so powerful that it incinerated people underground, created its own wind and weather, and moved faster than human beings could run. (Almost twice as many acres, nearly three thousand, were destroyed in San Francisco in 1906.) On August 6, 1945, in the culmination of the Manhattan Project, the first inhabited nuclear ground zero was created when the Enola Gay dropped an atomic bomb on the city of Hiroshima. The bomb killed somewhere in the neighborhood of a hundred thousand people in various terrible ways, some instantly, some slowly, and vaporized, shattered, irradiated, and ignited the central city. Three days later, another atomic bomb was dropped on Nagasaki. In the photographs of Yosuke Yamahata, Nagasaki doesn't look ruined, as San Francisco did after the earthquake; it looks shattered. Buildings have been torn into splinters and shards in which bodies lie, some of them charred; the force of the bomb is furious, vicious in ways the earthquake was not.

Hamburg, Dresden, Hiroshima, and Nagasaki are still cities, though not the cities they were. But the Second World War also changed American cities that were far out of reach of the war's violence. The war did much to lift the Great Depression and created a huge demand for factory and shipyard workers, prompting a colossal migration of African Americans from the

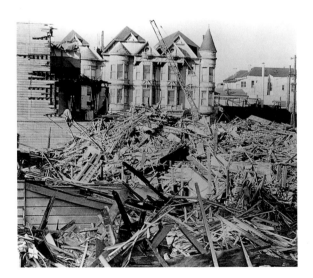

"Slum clearance" in the Western Addition, San Francisco, 1953.

rural South to the industrial cities. San Francisco's African American population increased ninefold between 1940 and 1950, and still more of these southerners migrated to nearby Oakland, Richmond, and Marin City to fill shipyard jobs. Pushed by discrimination and economics, many ended up in San Francisco's Western Addition, the flatlands west of City Hall and Van Ness Avenue, which had been partly vacated by Japanese Americans forced into prison camps for the duration of the war.

Ironically, this was the most central neighborhood to have survived the 1906 earthquake. It was made up largely of wooden Victorian row houses with intricate ornamentation, bay windows, and, often, storefronts built into the ground floor. After the quake, businesses and city administration had relocated to Fillmore Street, the central artery of the Western Addition, while the city to the east was rebuilt. Through the Second World War and afterward, Fillmore was a lively street of theaters, dance halls, and music clubs, frequented in the postwar years by some of the greatest jazz musicians of the time. By 1947, however, plans were being laid to erase this neighborhood. The word used over and over until it became a mantra and a justification was "blight," a word that was supposed to describe the poor condition of the housing and its alleged infestation by vermin but that was in fact a code word for the human inhabitants, just as "urban renewal" was recognized as code for what was also caustically described as "negro removal." The San Francisco Redevelopment Agency declared, "San Francisco is now developing programs to correct blighted and congested conditions and to deal with an accumulation of housing that is continuously aging and deteriorating faster than it is being rehabilitated or replaced. . . . More than 50 percent of the structures are past middle age with an estimated average age of sixty-seven years. It is this condition which results in neighborhood blight and calls for both major public improvement and private rehabilitation and reconstruction." Hundreds of wooden Victorian buildings were reduced to splinters, though preservationists managed to relocate some. The "past middle age" houses that survived redevelopment are now more than a century old, handsome, and worth more than a million dollars apiece.

Into the 1960s, campaigns to devastate this neighborhood were carried out. The rhetoric of urban renewal was that bad housing would be replaced with good housing—and good was defined in those squeamish modernist terms as efficient, up-to-date, and orderly. The truly urban mixing of classes, activities, and households was seen as disorderly, as almost a form of blight itself. (Interestingly enough, proponents of the "new urbanism" and other contemporary urbanists seek to restore those qualities of mixed use and vibrancy to the anesthetized cityscapes and suburbias of the modern era.) In fact, though a number of barracklike housing projects were built (most of which have been destroyed in the past several

Rebecca Solnit

years as inimical to safety and well-being, to be replaced by townhouses more closely resembling the earlier dwellings), many square blocks of the heart of the Fillmore were left vacant for decades, lots full of weeds, surrounded by Cyclone fences.

The agenda all along had not been the creation of better housing for the inhabitants but their replacement by more affluent inhabitants and profit for developers and landowners. This debacle and urban renewal's subsequent eradication of the South of Market residential hotels, inhabited largely by poor single retirees, particularly former union longshoremen and dockworkers, constitute the ninth destruction of San Francisco. Like the earlier destructions, this devastation was not complete, but it turned once densely inhabited expanses into wastelands and signified the end of an era—in this case, the era of San Francisco as a blue-collar town. (Earlier, some of San Francisco's elite had hoped to use the 1906 earthquake as an opportunity to relocate Chinatown, which had been pretty comprehensively destroyed, from the east flank of Nob Hill to a remote edge of the city; happily, they hoped in vain.)

Poverty as neglect produces ruin in itself—lack of maintenance leads to decay and eventually to ruins. But wealth is a more powerful scourge of cities, removing both buildings and inhabitants to replace them with more profitable versions of same. The Western Addition before urban renewal was shabby, but it was not in ruins. The wrecking balls, the splintered heaps of what had once been Victorian houses, the vacant lots, the displaced people—all were produced not by the poor but by the wealthy, who controlled urban policy. Or perhaps "wealth" and "poverty" are terms that create a false dichotomy; perhaps "distorted resource allocation" embraces both ends of a spectrum whose pervasive injustices produced urban renewals across the country, produced the ruins that still stand in Detroit and St. Louis and the erasures that made way for the shiny new Manhattans and San Franciscos of the present.

Let me again define "ruin." There is the slow process of entropy that transforms buildings into ruins, and there are the speedy acts of violent nature and violent social forces that immediately shatter buildings—earthquakes, bombs, wrecking balls. But whether the ruins stand, as the ruined abbeys of Henry VIII's Protestant Reformation stand all over rural England, is another question. When the land is valuable, the ruins are often themselves ruined, destroyed, erased.

One of the principal problems in making human beings face our history is that sudden events get our attention while slow ones do not—even though the cumulative force of, for example, global warming will prove far more dire for the Arctic than the Exxon-Valdez oil spill. Our minds are better suited to oil spills than climate change, and so are our media and our stories. The crash of the airplanes into the World Trade Center on September 11, 2001, is unforgettable, but the violent destruction of the South Bronx on a far larger scale throughout the 1970s and 1980s is barely remembered and will likely never elicit a memorial. Yet tens of thousands of intentionally set fires—many of them landlord arsons—devastated this community and turned block after block into ruins. There were an average of thirty-three fires a night in the first half of the 1970s; fires had increased dramatically since the early 1960s. In the last year that insurance companies paid out claims for fires, the Bronx lost about thirteen hundred buildings to flames. Then, "in the first year without payoffs," Marshall Berman reported, "it lost twelve. In the second year, it lost three." But the fires were never blamed on economic interests. Senator Daniel Patrick Moynihan voiced a typical sentiment when he wrote, "People don't want housing in the South Bronx, or they wouldn't burn it down."

The fires also raged on the Lower East Side and the Upper West Side, where a concerted program of urban renewal was also creating a huge wave of displacement. "For years," Berman recalled, "midnight fires ate up not only buildings but whole blocks, often block after block. Then we found out that, even as big parts of the city were burning down, their firehouses were being closed. . . . Through all these happenings, dozens of ordinary nice neighborhoods, like the one I grew up in, metamorphosed into gigantic, twisted, grotesque ruins. Diverse populations brought up to lead pallid but peaceful lives found themselves engulfed in pathologies, ending in unending early death." Later in this essay of searing outrage and stubborn loyalty, Berman added, "In the 1970s and 1980s, New York's greatest spectacles were its ruins. We couldn't believe the enormity of these ruins. They went on and on, for block after block, mile after mile. Some blocks seemed almost intact; but look around the corner, and there was no corner." Cardinal Terence Cooke—the Catholic Church was one of the few powers to fight the Bronx blitz—declared that "whole areas look like the burnt-out ruins of war. The ominous wail of sirens has become a terrifying part of people's lives. There is one building in the Bronx in which families live in constant fear because just last week the building next door was set on fire seven times."

Another writer, Luc Sante, came of age in New York in its age of ruins:

Already in the mid-1970s, when I was a student at Columbia, my windows gave out onto the plaza of the School of International Affairs, where on winter nights troops of feral dogs would arrive to bed down on the heating grates. Since then the city had lapsed even further. On Canal Street stood a five-story building empty of human tenants that had been taken over from top to bottom by pigeons. If you walked east on Houston Street from the Bowery on a sum-

mer night, the jungle growth of vacant blocks gave a foretaste of the impending wilderness, when lianas would engird the skyscrapers and mushrooms would cover Times Square. At that time much of Manhattan felt depopulated even in daylight.... In 1978 I got used to seeing large fires in that direction every night, usually set by arsonists hired by landlords of empty buildings who found it an easy choice to make, between paying property taxes and collecting insurance. By 1980 Avenue C was a lunar landscape of vacant blocks and hollow tenement shells.

What happened in New York was more dramatic and more visible (though it since seems to have been forgotten), but it paralleled the slow, violent death of the modern city and the industrial age across the United States, a death that was itself part of the larger passing of the utopian (and often socialist) belief in a rationalist, technological future that those cities once embodied. The old blue-collar cities of manufacturing and shipping were dying, to be replaced in some cases by sleek new cities dealing in information, of which San Francisco and Manhattan are among the most prominent. New York's ports moved to New Jersey; San Francisco's ports moved to Oakland and Long Beach; railyards closed, as did countless small urban manufacturing sites; jobs went overseas. A sort of forest succession stage took place: the abandoned sweatshops and manufactories became artists' lofts in San Francisco's South of Market and New York's Soho, and then lawyers and others more powerful than artists priced them out. Artists represented a sort of lull between two economies, as did the ruins, and perhaps both represented a moment of openness in the meaning and imagination of the city, a pause in urban busyness to wonder and reflect. Artists in these circumstances often became their communities' historians, servants of memory and thus of ruin.

The ruins: they were part of the San Francisco I came to inhabit in 1980. They no longer exist. They were a significant part of the cityscape of my youth, a cityscape of vacant lots and empty factories, of low-pressure

San Francisco anti-gentrification poster with image by Eric Drooker, 2000. (Susan Schwartzenberg)

zones in which housing was not so hard to come by and economic choices were not so anxiety-ridden. The ruins signified much to us in the 1980s, as under Ronald Reagan's nuclear brinksmanship we anticipated the end-of-the-world war. The apocalypse seemed close at hand, and the post-apocalyptic landscape was imagined as a landscape of ruins, the landscape of road warriors and terminators. But the ruins lay in the present, not in the future: we were not living before ruin but after it, after the ruin of the old cities that had been written about by people like Joseph Mitchell in his decades of *New Yorker* reportage, the blue-collar cities with room for everyone, the muscular, industrial cities that looked like the future in the first decades of the twentieth century and became the abandoned past by the last two or three.

The ruins were the backdrop—often literally—of punk rock and performance art; San Francisco's Survival Research Laboratories performed their rites of mechanical failure, their avant-garde demolition derbies between handcrafted machines, in parking lots, in vacant lots, and, at least once, at the site of an abandoned brewery that has been replaced by a Costco. (The movement from local beer production to the consumption of transnational products is one way to trace the trajectory of cities over the past several decades.) And the ruins were our psychic landscape: like Luc Sante, we who were young gloried in the liberatory spaces of abandonment and destruction, found in the ruins a mirror for our own wildness, our own desire to locate an outside to the strictures of society. I think back to that moment when the Portals of the Past framed not a mansion, not a garden, but a whole smoldering terrain, more tragic but also more wide open than before or after, a long pause between two phases, as ruins often are.

And then the ruins were gone—not all at once, but incrementally throughout the nineties, first in slow stages, then, in San Francisco, in a sudden rush of money as dramatic as any disaster. At the turn of the century, at the height of the dot-com boom, twenty million dollars a day of venture capital was being pumped into the Bay Area, and it swept away not just empty and abandoned spaces but also the poor, the eclectic, the alternative, small businesses, and nonprofits; drowned countless continuities, the small stores and elderly residents and longtime denizens who constituted the place's memory and links to the past. After decades of neglect, vacant lots everywhere filled up, as though the long, sighing exhale of loss had become a quick, choking inhale of cash. You walked down the street and saw a new hair salon or a Starbucks and tried to remember what it had replaced—a fried-chicken shop? an upholstery store? a storefront gospel church?—and then one day you walked down the street and didn't remember how new all this new San Francisco was. Photographers ran around like ethnographic photographers a century before, trying to pre-

serve some sense of the disintegrating communities. Sometimes, as if it had been a neutron bomb, this onslaught of wealth just destroyed the contents of buildings, their fragile residents forced out with their souvenirs and memories; sometimes it tore down less valuable buildings to replace them with ones that would yield more profit and accommodate other populations.

Tens of thousands of newcomers arrived to live not in the San Francisco they found but the San Francisco built out of their paychecks and stock options, a place full of brand-new bars and restaurants and boutiques, a place where condominiums—particularly pseudo-industrial lofts—were

Anti-gentrification poster by San Francisco Print Collective, 2000. (Susan Schwartzenberg)

springing up by the thousands, where nonprofits and small businesses, the economically marginal, and seniors and families were being evicted at a rate several times that of a few years earlier. I am never sure whether these newcomers were the barbarians sacking our Rome or whether they were the Romans—after all, they represented order and homogeneity and a consolidated future—sacking our Barbary Coast. But they came and they ravaged the city. Then, early in 2001, their technology bubble burst, leases went into default, rental prices that had increased astronomically sagged slightly, restaurants folded, and the boom became a bad memory or a bad case of amnesia. It was as though that futurist technological utopianism that had died out with modernism had lurched back to life, but not for long, not with a credible foundation.

I will talk about the 1989 earthquake soon, but it is not what I count as the tenth destruction of San Francisco. For me, that destruction was, like the ninth, economic: the sack of the city by wealth during the heyday of the dot-com boom, circa 1998–2001. Wealth did to us what poverty did to New York—or perhaps both could be identified as the same force, as greed (for it was not the poor but the landlords' profiteering that caused those Bronx and Lower East Side fires). Like all the previous destructions, this one did not destroy the city, but it destroyed *a* city, a slightly rougher, more diverse, more creative city that is gone forever (though the current city too is temporary, and not all of us were uprooted).

The first nine destructions created ruins; the tenth erased them in a frenzy of development, demolition, eviction, and replacement.

Where ought one to situate another invisible age of ruin, the generation of the armies of the homeless, who camp out as though the city was ruined, bombed, as though they are not the species for whom it was built, a crisis that has in two decades become the ordinary state of things for these

people who are themselves a ruin of sort, not of their own lives but of the civility that we used to believe aligned with citizenry and cities? Perhaps they are refugees from the cities that no longer exist, the industrial cities with uncomplicated jobs, unions, job security, blue-collar housing, New Deal and Great Society social programs, and stable networks. The structure of the Hibernia Bank at McAllister and Market Streets survived the 1906 earthquake. I believe it was still a bank at some point in my tenure in San Francisco, and then it was a police substation. But for many years it has been empty, and homeless people have sat on its steps, as though the city had never been rebuilt after the 1906 earthquake, as though generations had come of age in the ruins. They were there when Mark Klett photographed it. And then, the other day, I passed it and a set of mobile barricades had been erected around the broad, inviting corner steps so that the bank was truly abandoned, inside and out.

W. G. Sebald wrote of the erasure of Germany's wartime damage: "From the outset, the now legendary and in some respects genuinely admirable reconstruction of the country after the devastation wrought by Germany's wartime enemies, a reconstruction tantamount to a second liquidation in successive phases of the nation's own past history, prohibited any look backward. It did so through the sheer amount of labor required and the creation of a new, faceless reality, pointing the population exclusively towards the future and enjoining on it silence about the past." This is the silence more devastating than ruin.

Dream Series

On October 10, 1989, the *San Jose Mercury News* ran a huge headline the width of the newspaper that said simply "DREAM SERIES." It referred to the World Series games to be played between the Oakland A's and the San Francisco Giants, but it seemed to prophesy the Loma Prieta earthquake, which hit on October 17 during game three of the series, and the events that unfolded afterward. When the quake hit, I was sitting at my desk writing about the Kennedy assassination, and the initial moments were dramatic but not very interesting to recount. (The Loma Prieta was of about the same magnitude as the 1868 San Francisco earthquake, many times smaller than the 1906 quake.) Friends of mine who were outside, however, reported spectacular visions.

Kimo Bailey recalled:

I know exactly where I was at five o'clock on October 17: at the entrance to Golden Gate Park at the Arguello Gate. I was on Arguello Boulevard facing the park, so I was facing Santa Cruz and the origin of the quake. I was stopped at the stoplight and then I felt this bump and I thought some friend of mine had

come up behind me and had tapped my rear bumper. I looked in my rearview mirror and there was no car, and then it dawned on me it could quite possibly be an earthquake. And then I heard in the sky above me the swishing, the cutting, of the overhead wires for the electric buses. I could hear them swishing through the air like a blade cutting the air at high speed. And then I looked and all of Golden Gate Park was in motion. It was incredible. All the trees looked like they were fishing poles—if you shake a fishing pole they quiver from the bottom to the top and it looked like there was a high wind or some kind of incredible wind blowing, only there was no wind. There are two big columns, concrete columns, at the gateway to the park, and they were visibly moving from side to side. I could also hear the buildings in that neighborhood, which are all two- to four-story buildings, but close to each other—some two to three inches apart. I could hear the buildings racking against each other with this incredible noise which seemed to come from everywhere. The noise was like giants taking huge timbers and slamming them together but the noise also seemed to come from the sky and from the ground. It just came from everywhere. And as I looked I could see in the ground a wave coming through Golden Gate Park, about a foot, foot-and-a-half high, and it was coming directly at me. As it came through the park and the four lanes of Fulton Street, it lifted the roadbed. The ground seemed to give off a static charge. It looked like—if you pet a cat in the dark in the winter, as you run your hand over the fur you see charges of static electricity running up and down the cat—but the static electricity was so thick on the ground it looked like it was a layer of ice, almost. It looked to be half an inch to an inch radiating off the ground as the ground was cracking. As the wave passed under my car hitting my front tires first, it felt like being on a wave in the sea. So running east to west is the wide street called Fulton, and at 5:04 p.m. when the thing hit, the sun was low in the sky, and as I looked west to my right I saw that all the roadbed between me and the sun was in motion. It was like when you throw a stone into a lake and if the sun or moon is low you catch the sunlight or moonlight on top of the ripples and have a sparkling effect. Well, I saw the sparkle of the sun on the ground as the earth moved for, like, five seconds. It couldn't have lasted long. The whole event was fifteen seconds. And I looked at the traffic lights, and they were on for a second and then they went off. And I looked out the window next to me, and there was a 1967 or 1968 Cadillac convertible with two black guys from the neighborhood in it, and they looked at me, and I looked at them and said, "That was a fucking big earthquake!"

And they looked back at me and said in the same instant in the same voice, "We fucking love it."

Before the earthquake was a catastrophe, it was an event of almost supernatural strangeness.

Afterward, it was many things. Like many disasters, like the weather disasters—blizzards, hurricanes, floods—that are far more common elsewhere in the country, the 1989 earthquake seemed to snap a great many of us out of a certain kind of self-absorption—that concern about the self, about the personal, about long-term goals and inchoate unfulfilled desires—to pull us into a supercharged present. Political upheavals often have a similar effect that I think of as the euphoria of catastrophe, producing a sense of immediacy, absorption, selflessness, camaraderie, and connection for those who are on the edges, absorbed but not devastated or overwhelmed.

The annals of the 1906 earthquake are full of descriptions of this effect. Charles Sedgewick observed:

A spirit of good nature and helpfulness prevailed, and cheerfulness was common. . . . There was much kindliness. The old and feeble, the blind, the lame, were tenderly aided. The strong helped the weak with their burdens, and when pause was made for refreshment, food was voluntarily divided; the mild was given to the children, and any little delicacies that could be found were pressed upon the aged and the ailing. This goodness and self-sacrifice came natural to some, but even the selfish, the sordid and the greedy became transformed that day—and, indeed, throughout that trying period—and true humanity reigned. It was beautiful to behold, and gave one a glimpse of human kind in a new and a glorious light. Would that it could always be so! No one richer, none poorer than his fellow; no coveting the other's goods; no envy; no greedy grasping for more than one's fair share of that given for all.

Pauline Jacobson, a journalist, wrote in the *San Francisco Bulletin*:

Most of us since then have run the whole gamut of human emotions from glad to sad and back again, but underneath it all a new note is struck, a quiet bubbling joy is felt. It is that note that makes all our loss worth the while. It is the note of a millennial good fellowship. . . . In all the grand exodus. . . . Everybody was your friend and you in turn everybody's friend. The individual, the isolated self was dead. The social self was regnant. Never even when the four walls of one's own room in a new city shall close around us again shall we sense the old lonesomeness shutting us off from our neighbors. Never again shall we feel singled out by fate for the hardships and ill luck that's going. There will always be that other fellow.

And that is the sweetness and the gladness of the earthquake and the fire. Not of bravery, nor of strength, nor of a new city, but of a new inclusiveness.

The joy in the other fellow.

A young woman wrote to her sister, "Everybody talks to everybody else. I've added hundreds to my acquaintance without introductions." A schoolteacher, Eric Temple Bell, reported, "The best thing about the earthquake

and fire was the way the people took them. There was no running around the streets, or shrieking, or anything of that sort. Any garbled accounts to the contrary are simply lies. They walked calmly from place to place, and watched the fire with almost indifference, and then with jokes, that were not forced either, but wholly spontaneous." In a way, a social utopia rose in the ruins of the city; when the city was rebuilt, the utopia was ruined. As a social rather than an architectural construct, it left no visible traces, no ruins to be commemorated, but it suggests that the rebuilt city was rebuilt as a ruin of greater possibilities.

Unlike 1906, when as many as five thousand people may have died, in 1989 casualties were low—about sixty people—for an earthquake of this magnitude in a densely inhabited area. The main casualties were on the collapsed Nimitz Freeway, an Oakland overpass built on swampy ground that divided an impoverished inner-city community, as so many elevated freeways have from New York to L.A. Nimitz had been an admiral; the broad street-level avenue that replaced the Nimitz was named Mandela Boulevard. This was the year of Tiananmen Square in China; the Velvet Revolution in Prague; the fall of the Berlin Wall; the liberation of Hungary, Czechoslovakia, Poland, and East Germany from Soviet domination; and the beginning of the end of the Soviet Union. It was a year of gargantuan change, of earthquakes in politics and in possibilities, and a year of living in public, of feeling that sense of being part of something larger. Somehow the earthquake, a few weeks before the less literal fall of the Berlin Wall, was part of that. Time is often pictured passing at a steady rate, as an uninterrupted stream, but it could as easily be imagined as a continental plate slipping and jamming: sometimes everything happens at once, sometimes time becomes dense with events. The geologist Clarence King called this "punctuated equilibrium."

In the hours and days after the 1989 quake, people stopped their ordinary routines. The night of the quake, the liquor store across the street from me held a small barbecue, since power was out everywhere. My brother came by to check on me and borrow a white shirt to wear as he directed traffic; no traffic signals were working. I talked to the neighbors, sat and watched the news on someone's portable television, and, after a few forays to see what was going on—the plume of smoke rising from the Marina fire was magnificent—settled in at home with a kerosene lamp and battery radio. (For weeks afterward, we would sit in the comfort of our homes watching news stories suggesting that all San Francisco was devastated. My own neighborhood suffered little more than cracks in brick chimneys and staircases.) That night, the powerless city lay for the first time in many years under a sky whose stars were not drowned out by electric lights.

In the morning, I walked around and visited people. It was not just because the Bay Bridge was out that many of us chose to stay close to home for weeks or months afterward; it was because the quake had somehow jolted us into the here and now, and a certain far-seeing restlessness, always on to the next thing and to elsewhere, was temporarily suspended. We were fully present and fully connected. There were aftershocks for months that became part of our dreams and anxieties—the earthquake was not pleasant, by any means, but the sense of scale and connection it gave us was profound.

Just before the quake, the *New Yorker* had carried an article by a man who insisted that when he sat at his desk in his rural home, he was utterly alienated from nature. Nature had come in and shaken my desk and wiped out the power on my computer as I was typing, and I felt the better for it. Some of the dread of our time is of being too powerful, too capable of dominating and destroying nature. The earthquake demonstrated a nature that was more powerful than atomic bombs, that shook us back into what human beings have been for most of time, small in the face of elemental powers. This smallness is a liberation and a measure of safety, not for individual survival but for the larger order of things. It is akin to that taste for the sublime that arose in the mid-eighteenth century, at a moment when Europeans were first beginning to dominate nature and seemingly first welcomed being overwhelmed as a check on their powers.

Not everyone felt that way about it. At the end of October 1989, I saw one of my neighbors, the male half of a couple usually curled up next door in junkie hibernation against the light and the world, carrying stereo equipment downstairs. "Why are you moving?" I asked, and he retorted, "Isn't it obvious?" A true San Franciscan, I asked if the rent had gone up, and he looked at me and said, "Where we come from, the earth doesn't move."

Where I live it does.

The Ruins of Memory

Photographs preserve memory, but they do so within severe limits. The ruins of San Francisco's 1906 earthquake survive as photographs, but they became part of the body of knowledge buried or set aside after the crisis was over. The ruins that count stand as witnesses, as public monuments, unavoidable parts of the shared terrain of everyday life, the presence of the past. Photographs are often cached away, viewed only by those who seek out the past and its complicating narratives; and their viewing is, except in major exhibitions, essentially private. Too, these black-and-white photographs of San Francisco in the hours and days following the disaster show a very specific version of the aftermath of what happened, one without color, without sound, largely without people. After exploring the ruins,

Louise Herrick Wall wrote: "Strange and terrible as is the destruction, San Francisco was never so nearly beautiful. There is no blackening of the ruins; the heat seems to have been so intense that it consumed all its own smoke and charcoal, leaving faintly colored surfaces of crumbled iron, marble, and brick. The ruins stretch out in the softest shades of pink and fawn and mauve, making the wasted districts look like a beautiful city a thousand years dead—an elder Troy or Babylon."

The relationship between photography and ruins is a tangled one. It is tempting to say that photographs function as ruins, not least because the ruins that have vanished elsewhere survive there. On the one hand, both function as traces of the past, prompters of memory; but ruins are mutable, inescapable, and immovable: the ruin stands as testament to the event in that very place, not merely subject to the forces at play there but marking the site. On the other, photographs are eternally reproducible and infinitely displaceable in their portability, transcending time as well as recording it. Always retrospective, they do not become ruins themselves but turn anything photographed into a ruin—at least in the sense that the minute it is photographed, a record exists of the subject at a state prior to its current state, evidence of its change. The nostalgia that a photograph taken even earlier the same afternoon can provoke is familiar: happiness can already look unrecoverable, part of a golden era now fled, sometime between lunch and the drive home. In this sense, photographs are not at all like ruins, except in their constant reminder of the passage of time. Their permanence is another measure of the impermanence of everything else. Rephotography is a sort of caliper for measuring the distance between this moment and that, between two moments, both now past, that record for us the strange ways time passes.

Often, recorded images seem to be a substitute for memory. There is the vacationer videotaping his experience out of both abhorrence at the fleetingness of all things and an often-mistaken sense that he will watch it later and truly know where he has been. There is the modern state of seeming to remember as experience what has been known only as image or footage. There is the way that photographs become repositories of memory, and by that token our memories cease to be such repositories. That is to say, a photograph records a moment and is often taken as grounds to believe that therefore the mind need not do so, that the photograph is not augmentation of the mind but replacement of it in some sense, as all material recordings of knowledge, information, and appearance are, since drawing, since writing. But photography's relationship brought a new specificity to this task of preservation. As Roland Barthes observed:

Every photograph is a certificate of presence. This certificate is the new embarrassment which its invention has introduced into the family of images. . . . Perhaps we have an invincible resistance to believing in the past, in History, except in the form of myth. The Photograph, for the first time, puts an end to this resistance: henceforth the past is as certain as the present, what we see on paper is as certain as what we touch. It is the advent of the Photograph—and not, as has been said, of the cinema—which divides the history of the world.

The divide is a fault line through memory, just as photography is a bridge to the past.

In the early years of photography, the stereoscope enthusiast Oliver Wendell Holmes rejoiced in the transcendental ability of photographs to capture appearances and dematerialize form:

Form is henceforth divorced from matter. In fact, matter as a visible object is of no great use any longer, except as the mould on which form is shaped. Give us a few negatives of a thing worth seeing, taken from different points of view, and that is all we want of it. Pull it down or burn it up, if you please. . . . Matter in large masses must always be fixed and dear; form is cheap and transportable. We have got the fruit of creation now, and need not trouble ourselves with the core.

What is radical and alarming about Holmes's exclamation is that it asserts photography as grounds for abandoning things in themselves, for accepting the substitute of images, for crawling back into Plato's cave and the world of simulations and representations, for a world of postcards of places rather than places, for a ruin of the aura of the actual and an acceptance of the substitutes. How flickering, how fluid, how manipulable that world would become, Holmes did not seem to imagine.

Take, for example, the pulling down of the statue of Saddam Hussein in Baghdad in the early days of the recent U.S. war on Iraq: the photographic image became propaganda for liberation in a city that was being ruined and erased, its archives, library, and museum destroyed in the same phase that saw the statue topple. But the permanence of photographs bespeaks other qualities. The footage of the toppling statue survives into an era when it means something entirely different. If anyone is to remember that Charleston and Atlanta were destroyed in the Civil War, that Hiroshima and Nagasaki were destroyed in the Second World War, photographs will buttress and flesh out that endeavor. In his essay "Irresistible Decay: Ruins Reclaimed," Michael S. Roth noted of Paris in the aftermath of the 1871 revolution, "It was a dozen years before the government made up its mind to destroy the monument to destruction that was the Tuileries and to restore it only as a purely historical building whose messages were

to be confined to lessons about the past rather than future political possibilities. The remarkable photographs of the Commune remain as emblems of ruins with which it proved too difficult to live."

So here returned are the reminders that San Francisco has been utterly destroyed and could be, will be, again. And, perhaps, as the rephotographs demonstrate, rise again, in a new form, yet unimaginable.

Notes

"Decay can be halted...": J. B. Jackson, "Looking at New Mexico," in *Landscape in Sight: Looking at America,* ed. Helen Lefkowitz Horowitz (New Haven, Conn.: Yale University Press, 1997), 62.

Victor Hugo poem quoted: Walter Benjamin, *The Arcades Project,* trans. Howard Eiland and Kevin McLaughlin (Cambridge, Mass.: Belknap Press, 1999), 95.

"This was the first of the great fires which devastated San Francisco...": Frank Soulé, John H. Gihon, and James Nisbet, *The Annals of San Francisco* (New York: D. Appleton, 1855), 241.

"But in proportion to the unusual depression...": Soulé, Gihon, and Nisbet, *Annals of San Francisco,* 277–278.

"Elsewhere such a fire might well be called a great one...": Soulé, Gihon, and Nisbet, *Annals of San Francisco,* 299.

"Sour, pseudo-religious folk on the shores of the Atlantic...": Soulé, Gihon, and Nisbet, *Annals of San Francisco,* 333.

"successively destroyed nearly all the old buildings and land-marks of Yerba Buena...": Soulé, Gihon, and Nisbet, *Annals of San Francisco,* 345.

"The lives lost yesterday are not chargeable to the earthquake...": *San Francisco Morning Call,* October 22, 1868.

"The aim of Operation Gomorrah, as it was called...": W. G. Sebald, *On the Natural History of Destruction,* trans. Anthea Bell (New York: Random House, 2003), 26.

"San Francisco is now developing programs...": Leonard S. Mosias for the San Francisco Redevelopment Agency, "Residential Rehabilitation Survey Western Addition Area 2," July 1962, unpaginated, San Francisco Public Library collection.

An average of thirty-three fires a night in the first half of the 1970s: Brian Wallis, ed., *If You Lived Here: The City in Art, Theory, and Social Activism—A Project by Martha Rosler* (Seattle: Bay Press, 1991), 288.

"in the first year without payoffs...": Marshall Berman, "New York (New York City)," in *These United States,* ed. John Leonard (New York: Nation Books, 2003), 299.

"People don't want housing in the South Bronx...": Senator Daniel Patrick Moynihan quoted in Jill Jonnes, *We're Still Here: The Rise, Fall, and Resurrection of the South Bronx* (Boston: Atlantic Monthly Press, 1986), 92.

"For years, midnight fires ate up not only buildings...": Berman, "New York (New York City)," 288.

"In the 1970s and 1980s, New York's greatest spectacles...": Berman, "New York (New York City)," 294.

"whole areas look like the burnt-out ruins of war...": Cardinal Terence Cooke quoted in Jonnes, *We're Still Here,* 264.

"Already in the mid-1970s...": Luc Sante, "My Lost City," *New York Review of Books,* November 6, 2003, 34.

"From the outset...": Sebald, *Natural History of Destruction,* 7.

"A spirit of good nature and helpfulness prevailed...": Charles Sedgewick quoted in *Three Fearful Days: San Francisco Memoirs of the 1906 Earthquake and Fire,* ed. Malcolm E. Barker (San Francisco: Londonborn Publications, 1998), 209.

"Most of us since then have run the whole gamut of human emotions...": Pauline Jacobson, "How It Feels to Be a Refugee and Have Nothing in the World," *San Francisco Bulletin,* April 29, 1906.

"Everybody talks to everybody else....": Catherine Golcher quoted in Barker, *Three Fearful Days,* 271.

"The best thing about the earthquake and fire...": Eric Temple Bell quoted in Barker, *Three Fearful Days,* 143.

"Strange and terrible as is the destruction...": Louise Herrick Wall quoted in Barker, *Three Fearful Days,* 201.

"Every photograph is a certificate of presence....": Roland Barthes, *Camera Lucida: Reflections on Photography,* trans. Richard Howard (New York: Noonday Press, 1981), 87.

"Form is henceforth divorced from matter....": Oliver Wendell Holmes, "The Stereoscope and the Stereograph," *Atlantic Monthly,* June 1859, 747.

"It was a dozen years before the government made up its mind...": Michael S. Roth, "Irresistible Decay: Ruins Reclaimed," in *Irresistible Decay: Ruins Reclaimed,* ed. Michael S. Roth, Claire Lyons, and Charles Merewether (Los Angeles: Getty Research Institute, 1997), 8.

PHOTOGRAPHS

Plates 1A, 1B, and 1C

THREE PANORAMAS OF UNION SQUARE DURING AND AFTER THE FIRE.

"THE BURNING OF SAN FRANCISCO, APRIL 18, VIEW FROM ST. FRANCIS HOTEL," 1906.
"FROM ST. FRANCIS HOTEL," 1906.
"PANORAMA OF UNION SQUARE FROM THE ROOF OF THE ST. FRANCIS HOTEL," 2003.

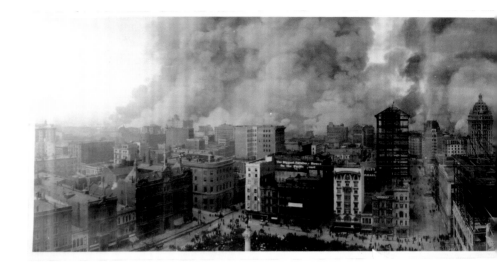

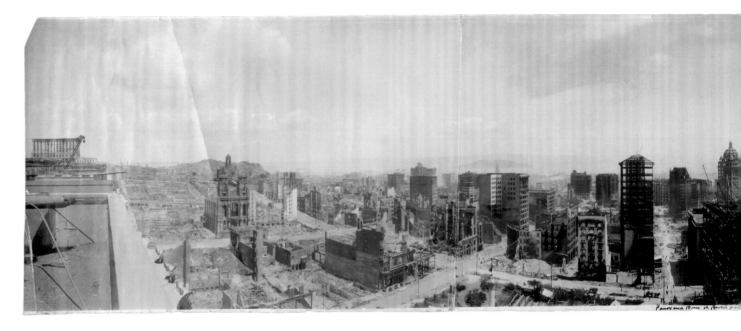

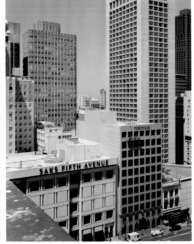
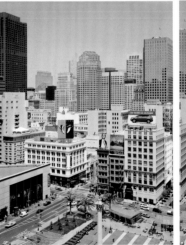
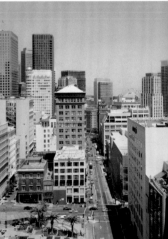

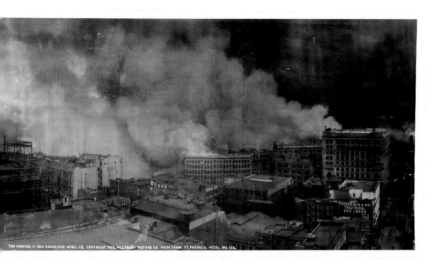

THE BURNING OF SAN FRANCISCO APRIL 18. COPYRIGHT 1906 PILLSBURY PICTURE CO. VIEW FROM ST. FRANCIS. HOTEL. No. 198.

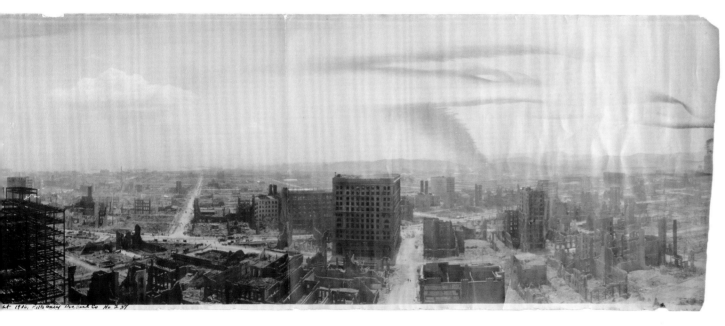

ht 1906, Pillsbury Picture Co No 2 37

Plates 2A and 2B

"THE VIEW FROM THE FERRY TOWER," 2003.
"MARKET ST. FROM FERRY," 1906.

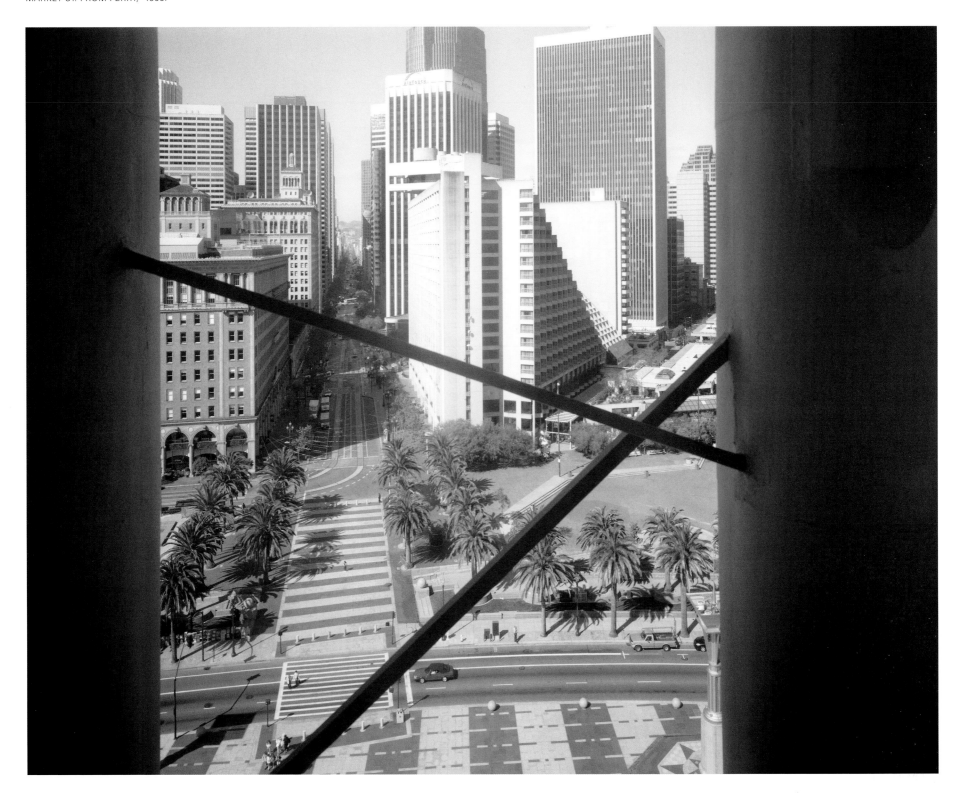

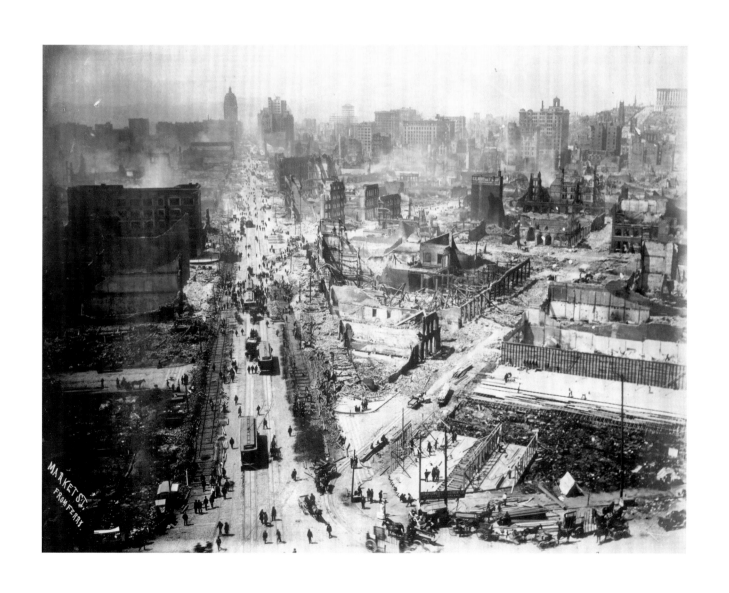

"THE FERRY BUILDING FROM THE EMBARCADERO," 2004.
"EAST ST., A FEW WEEKS AFTER THE FIRE. U.S. ARMY MEN BIVOUACKED IN TENTS," 1906.

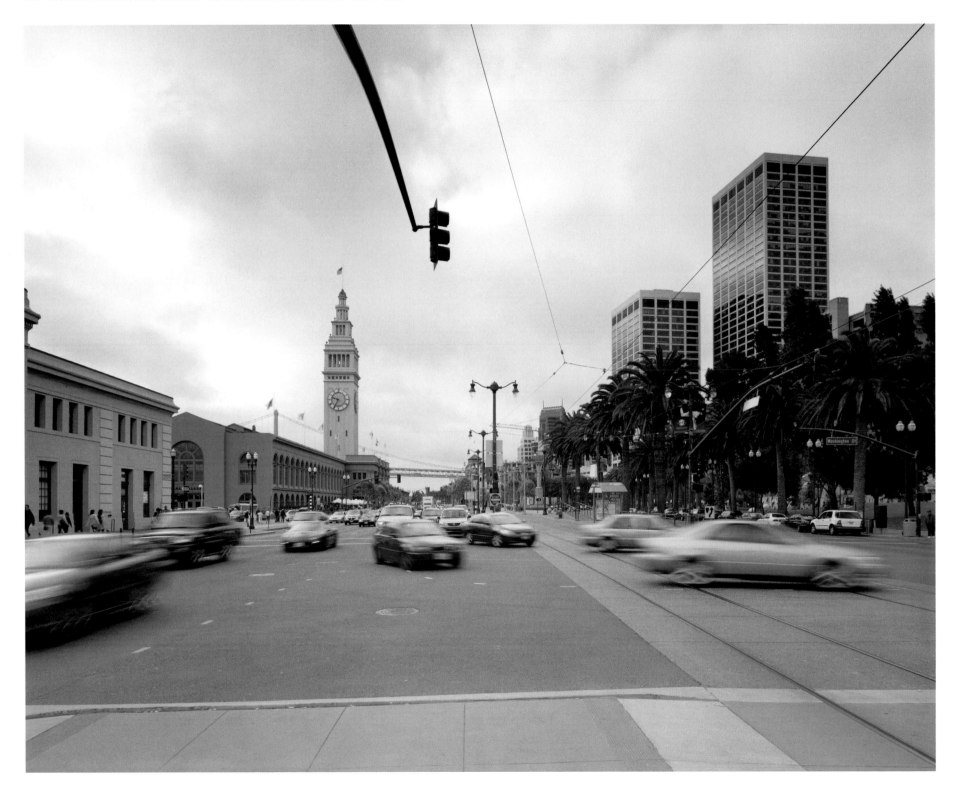

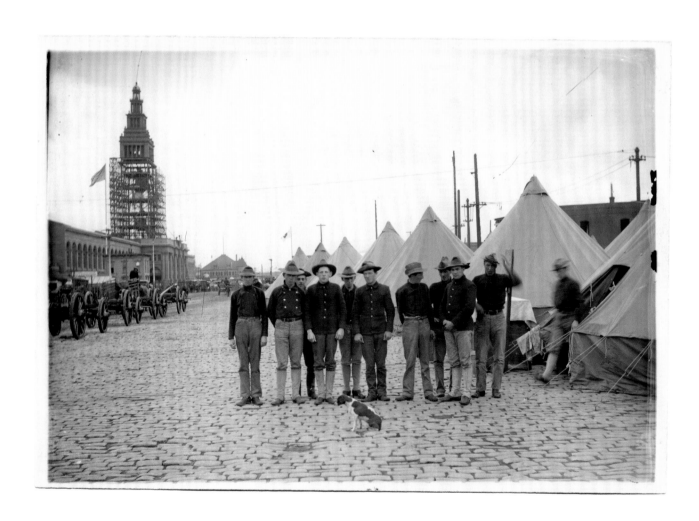

Plates 4A and 4B

"THE REFURBISHED CALL BUILDING FROM THE FRONT OF THE VIRGIN RECORD STORE, MARKET STREET," 2003.
UNTITLED, 1906.

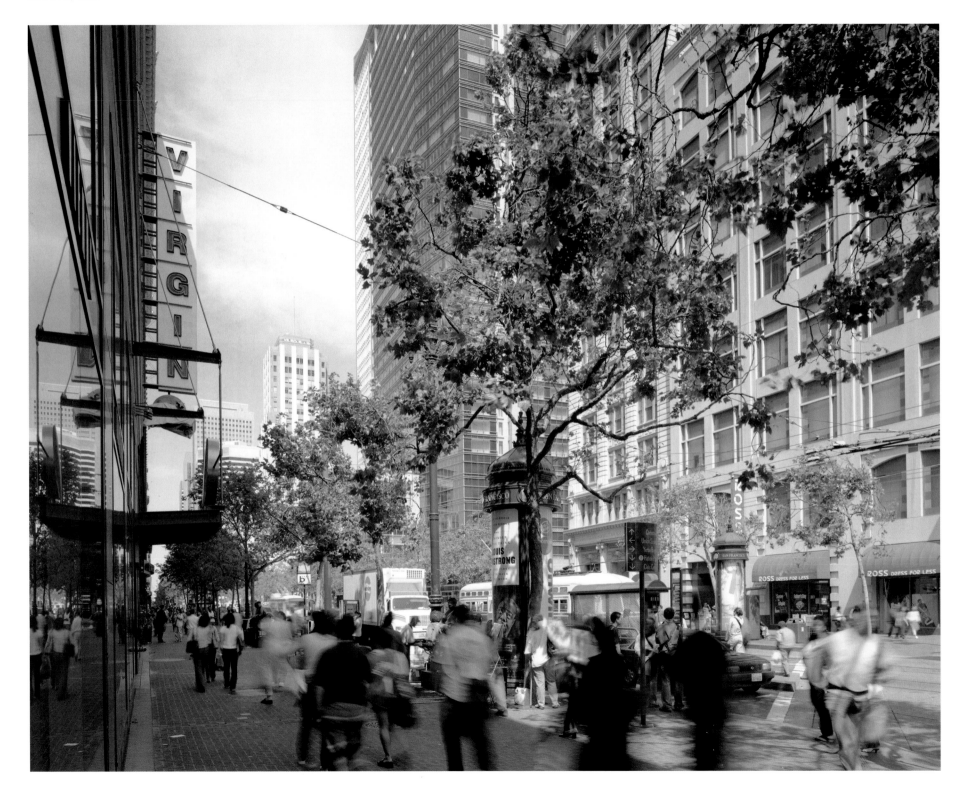

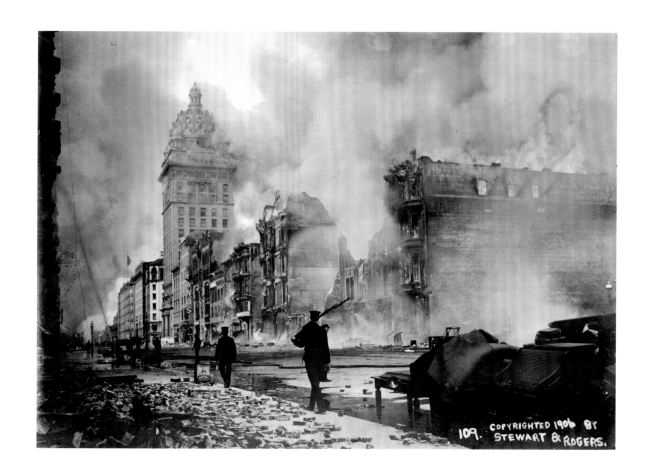

COPYRIGHTED 1906 BY
109. STEWART & ROGERS.

"THE CALL BUILDING WITH
DECO FAÇADE, MARKET AND
THIRD STREETS," 2003.

"BURNING OF THE CALL BUILDING.
LOTTE'S *[SIC]* FOUNTAIN," 1906.

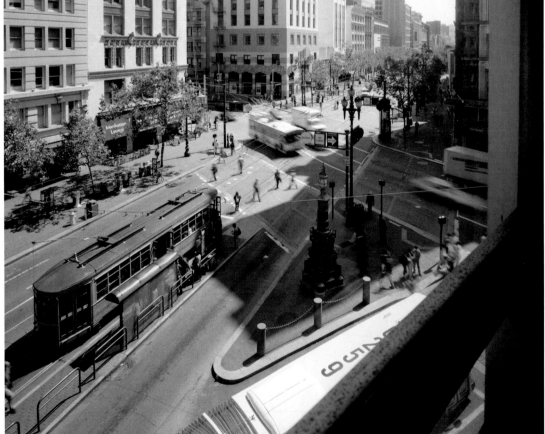

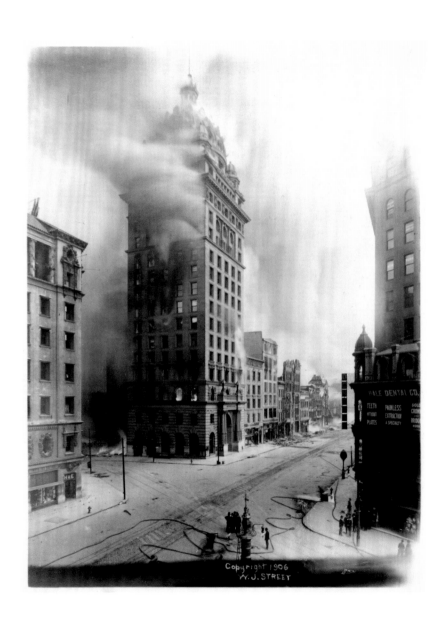

Copyright 1906
W. J. STREET

Plates 6A and 6B

"HEARST BUILDING, MARKET STREET," 2003.

UNTITLED (REMAINS OF THE HEARST
BUILDING AT MARKET STREET AND
THIRD STREET), 1906.

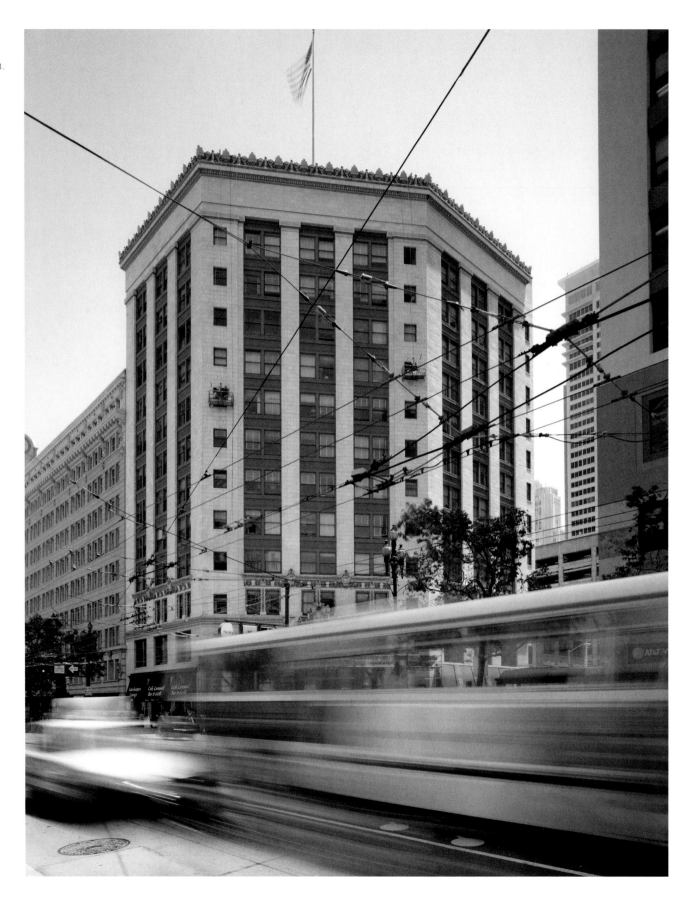

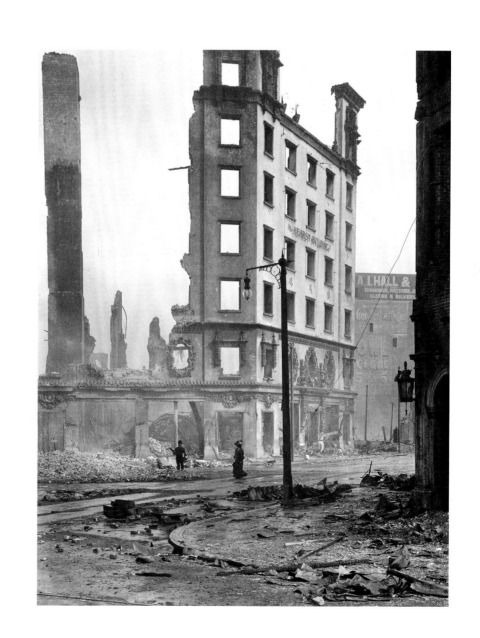

"THE PALACE HOTEL FROM THE MIDDLE OF GEARY STREET," 2003.
"PALACE HOTEL," 1906.

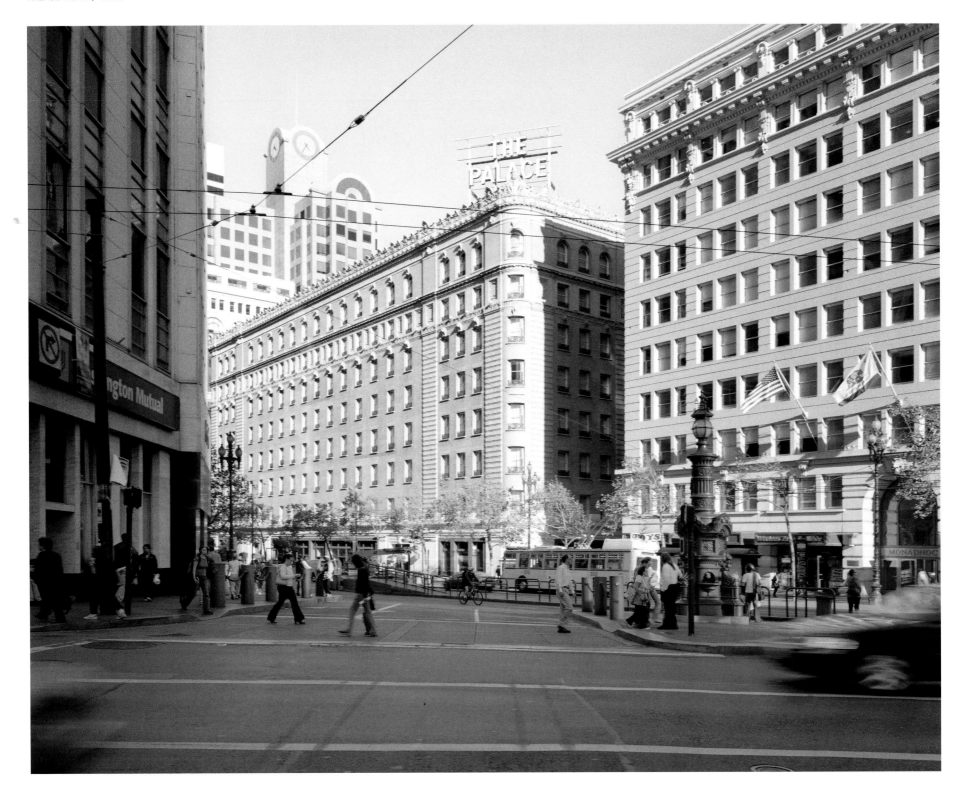

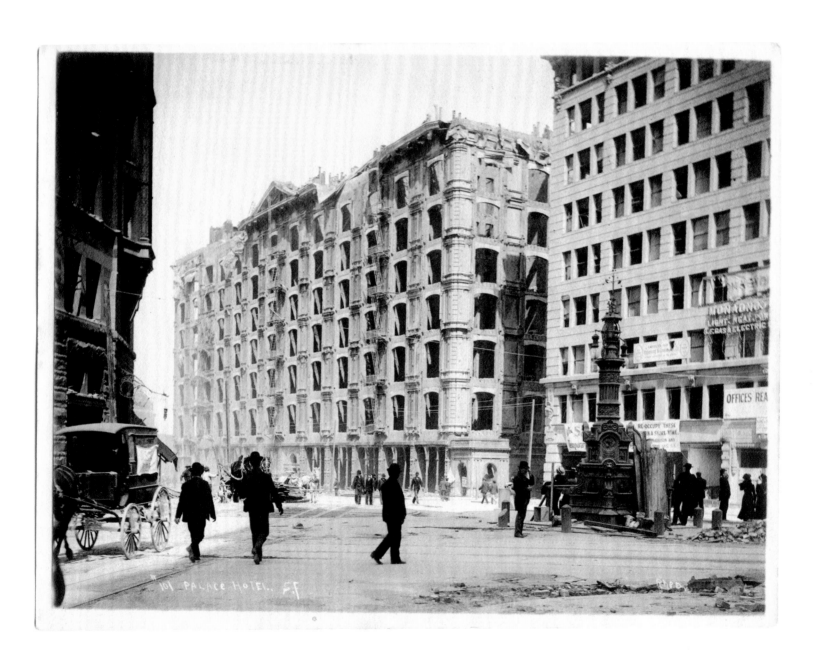

101 PALACE HOTEL SF

"BIKE MESSENGER HANGOUT, DONAHUE MEMORIAL, MARKET STREET AND BATTERY," 2003.
"DONAHUE FOUNTAIN, MAY 19, 1906."

DEDICATED TO MECHANICS
BY JAMES MERVYN DONAHUE
IN MEMORY OF HIS FATHER
PETER DONAHUE

HAVANA CIGAR
REGENSBURG &

NO. 48 DONAHUE FOUNTAIN. MAY 19, 1906.

Plates 9A and 9B

"PANORAMA VIEW FROM NEAR
TURK AND MARKET," 1906.

"SIDEWALK PANORAMA FROM
ACROSS THE INTERSECTION OF
MARKET AND TURK STREETS," 2003.

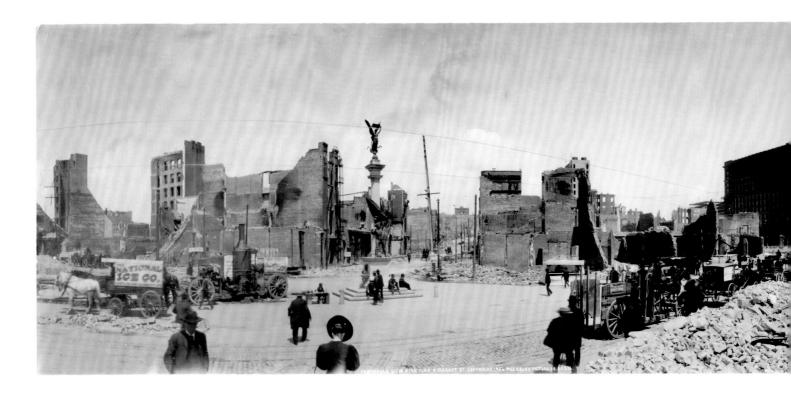

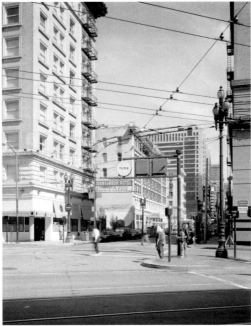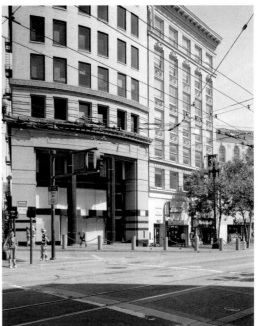

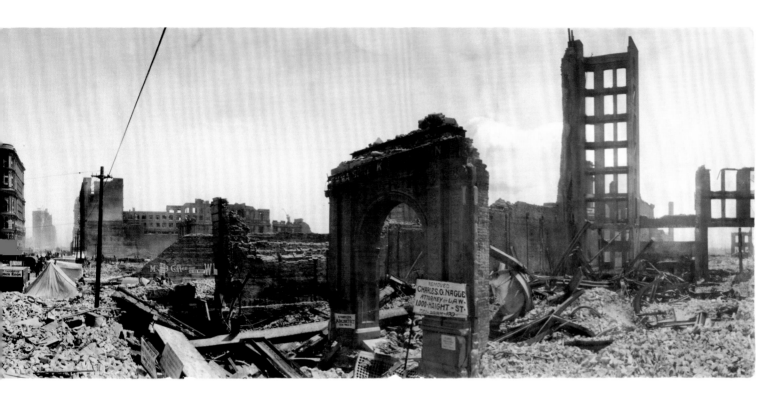

Plates 10A and 10B

"FLOOD BUILDING AND URBAN OUTFITTERS, CORNER OF POWELL AND ELLIS STREETS," 2003.
"FLOOD BUILDING," 1906.

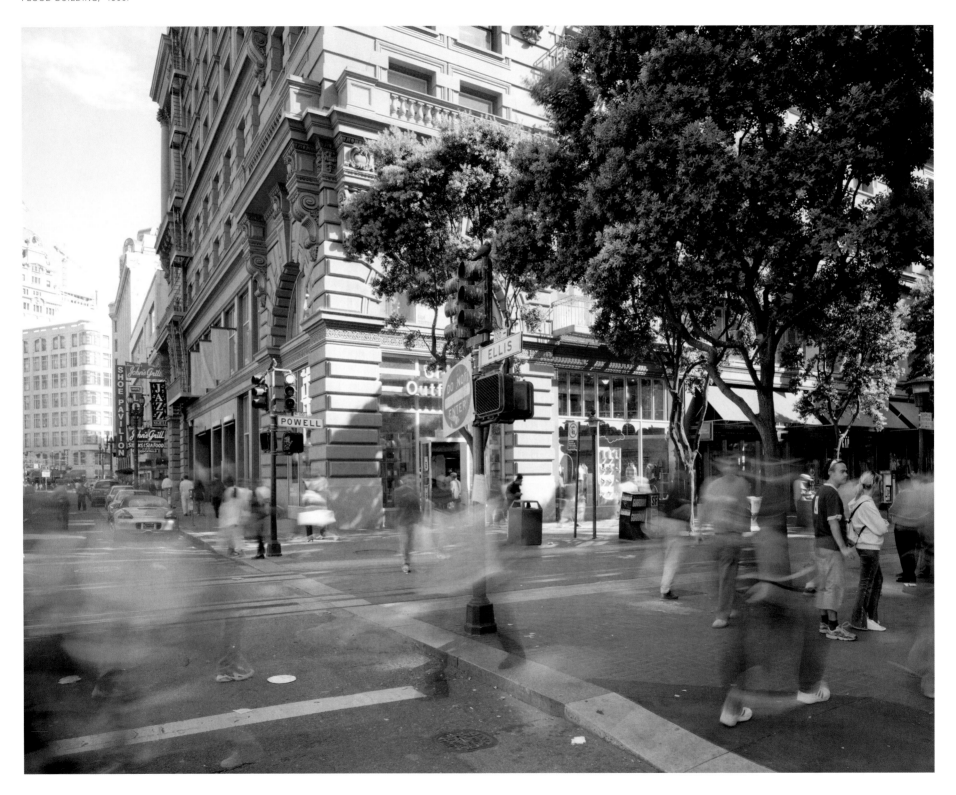

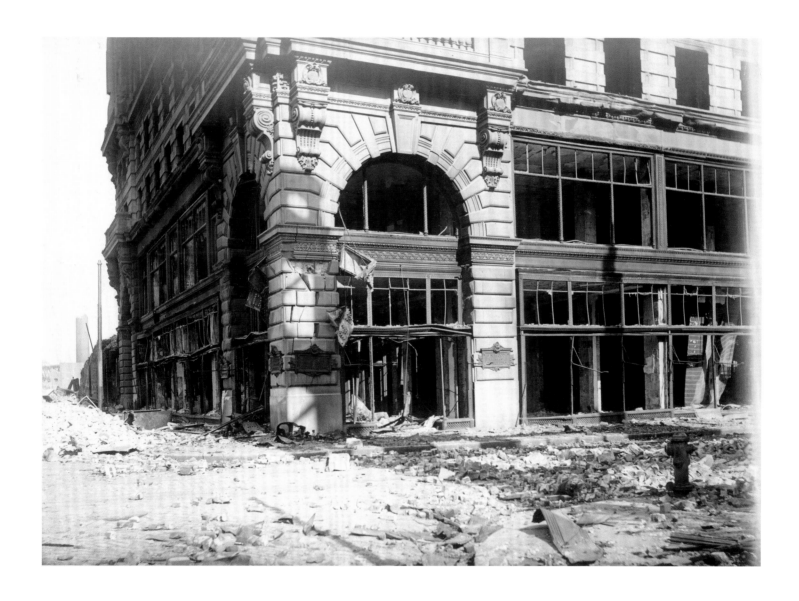

"THE INTERSECTION OF POST AND KEARNY FROM THE MIDDLE OF THE KEARNY STREET CROSSING," 2003.
"POST ST. AND KEARNEY *[SIC]*," 1906.

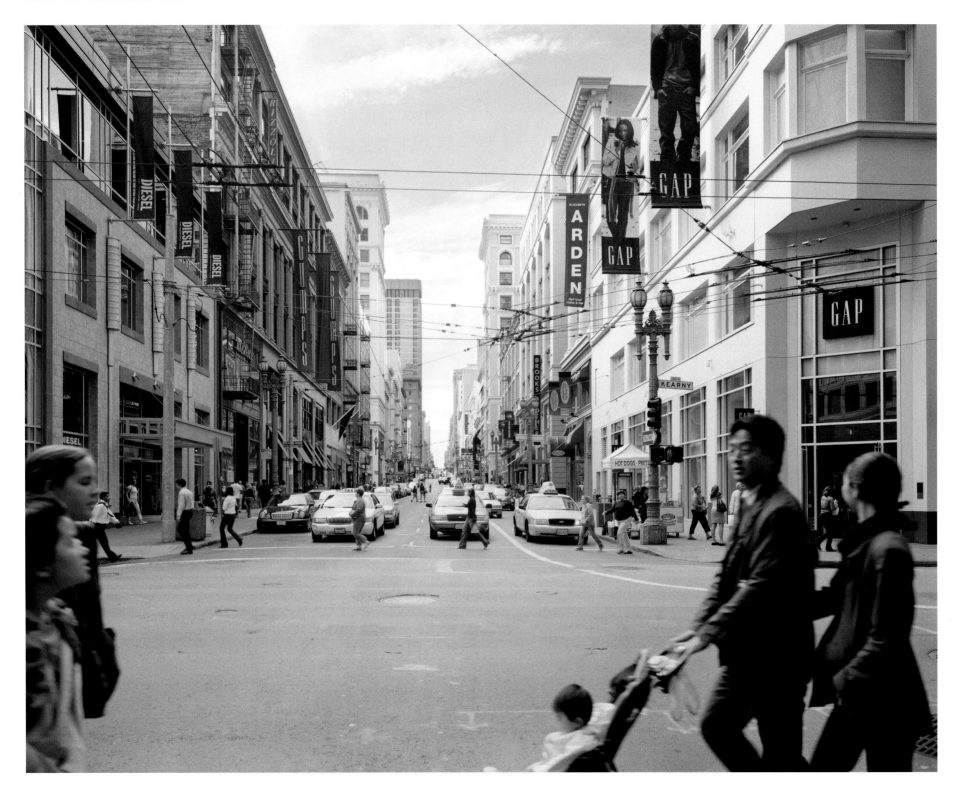

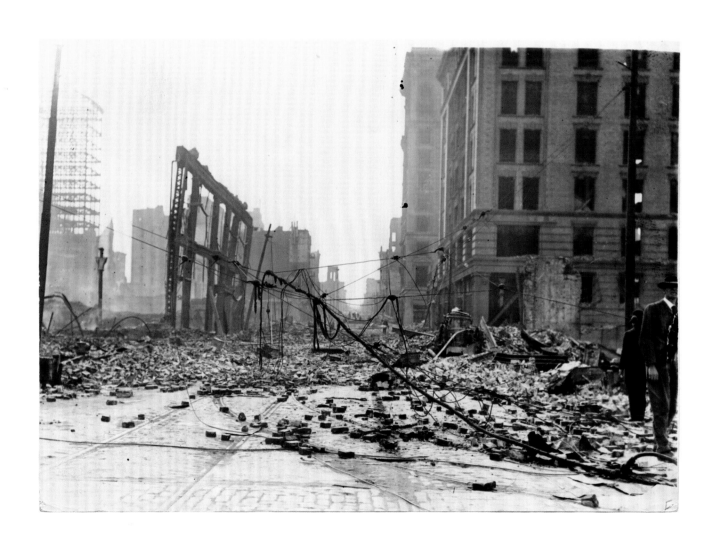

Plates 12A and 12B

"MILLS BUILDING, MONTGOMERY AND BUSH STREETS," 2004.
UNTITLED, 1906.

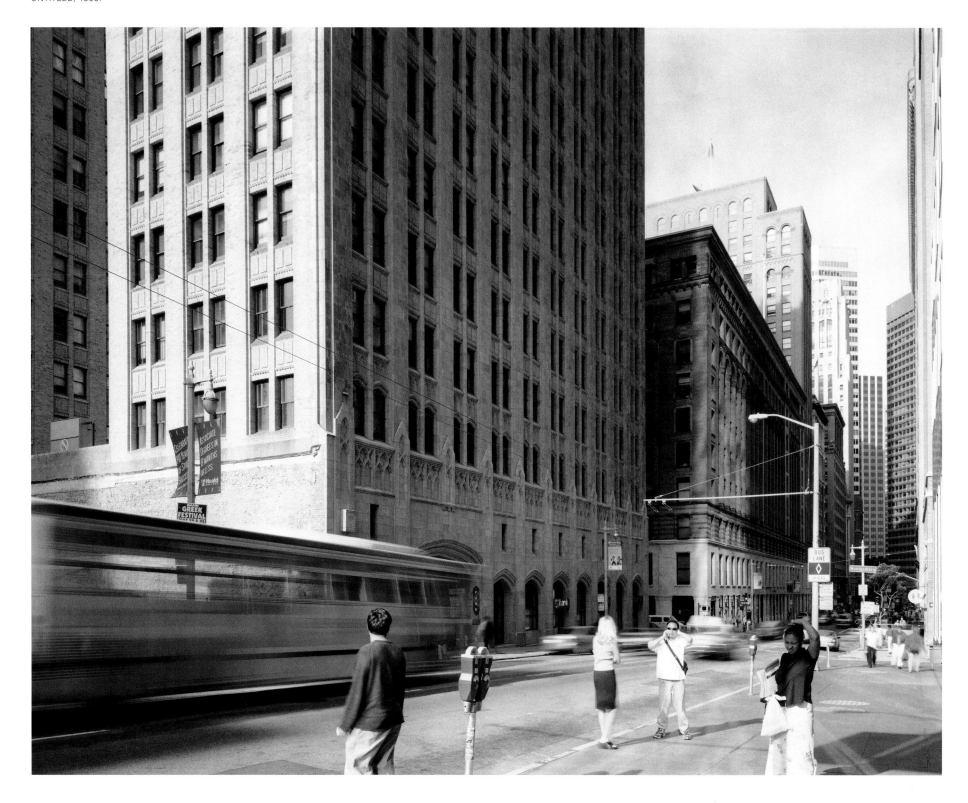

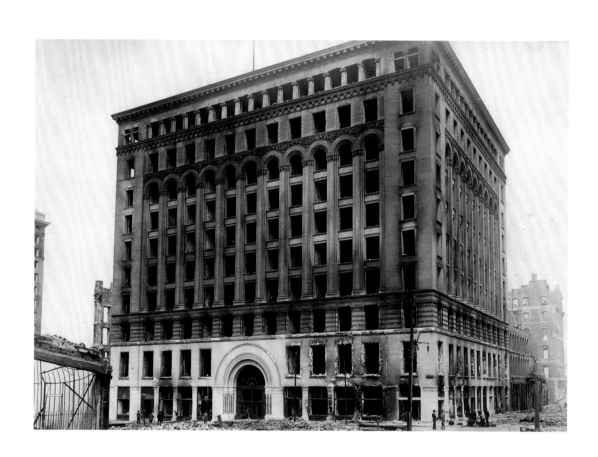

"TAXIS ALONG CALIFORNIA STREET, KOHL BUILDING," 2003.
"KOHL BUILDING," 1906.

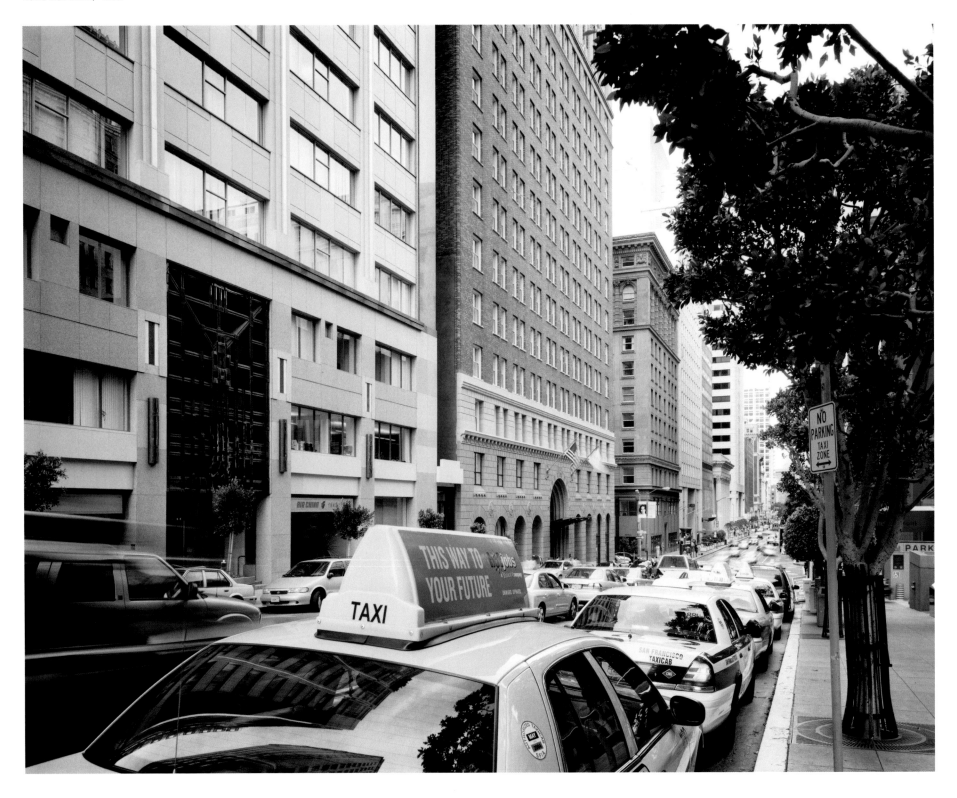

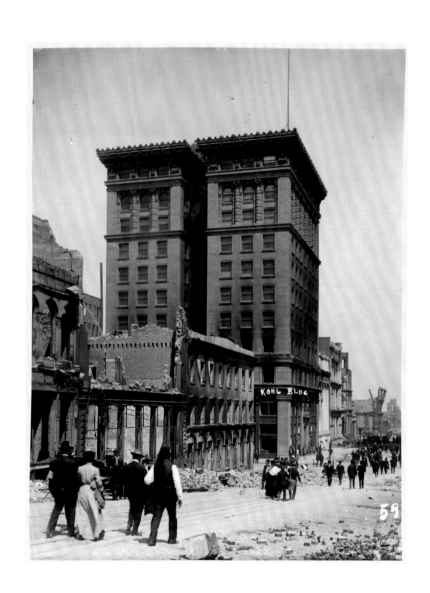

"'RELOCATION SALE,' CORNER OF POWELL AND O'FARRELL STREETS," 2003.
"POWELL & O'FARRELL STS.," N.D.

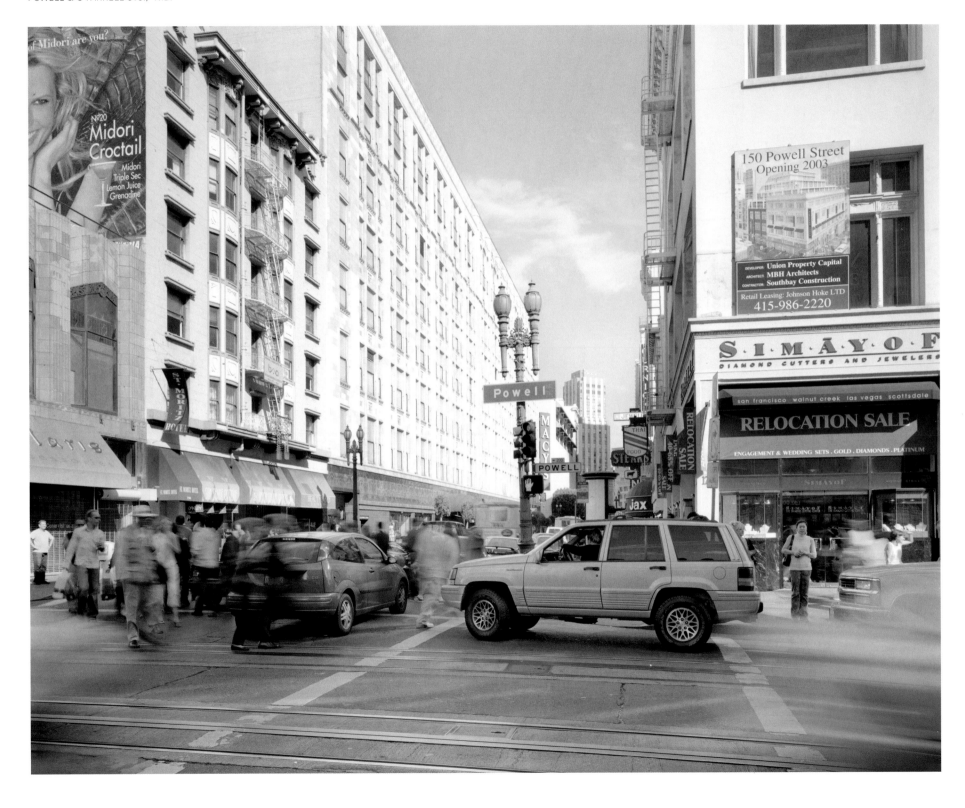

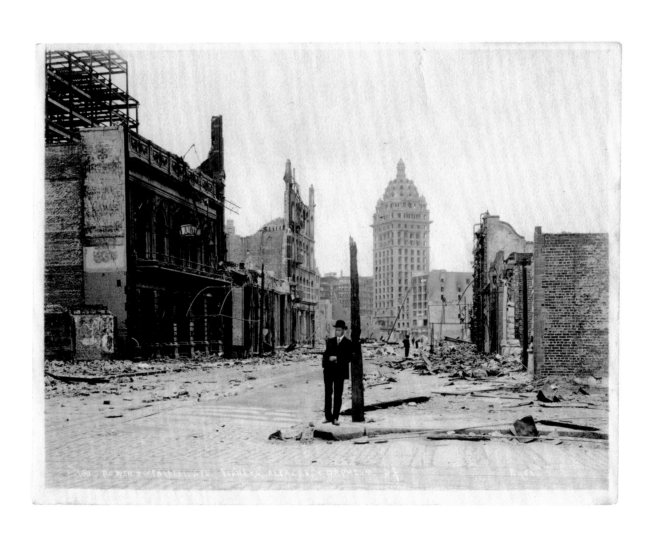

Plates 15A and 15B

"CABLE CAR LINE, CORNER OF GEARY AND POWELL STREETS," 2003.

"POWELL ST. NEAR GEARY, FIRE EFFECT," 1906.

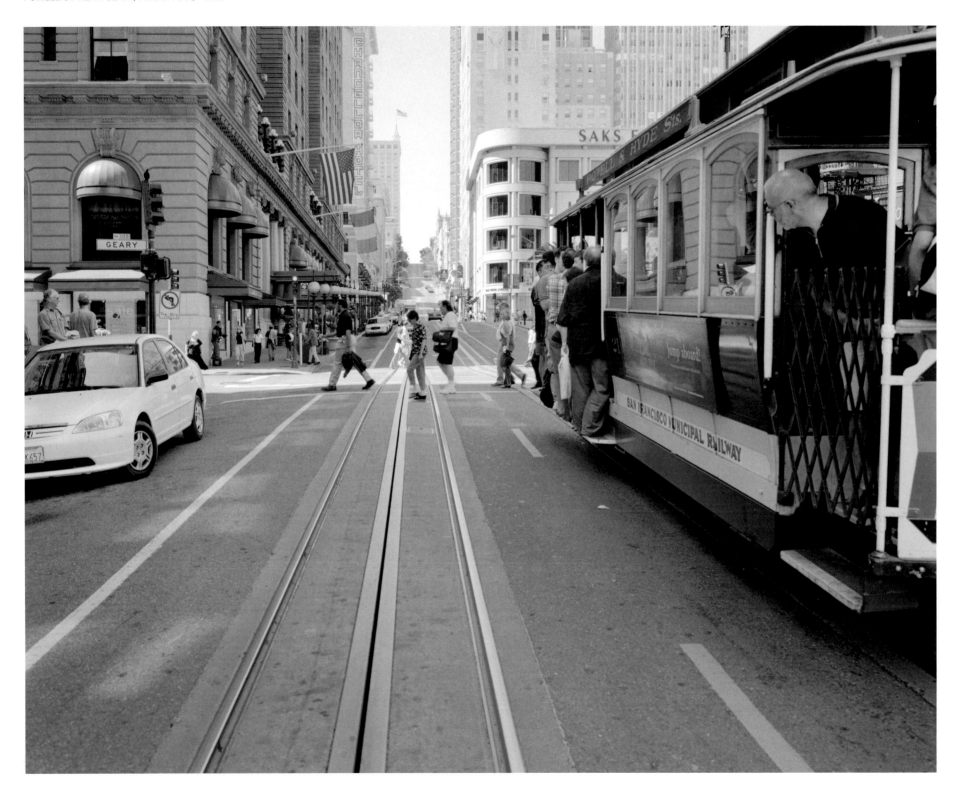

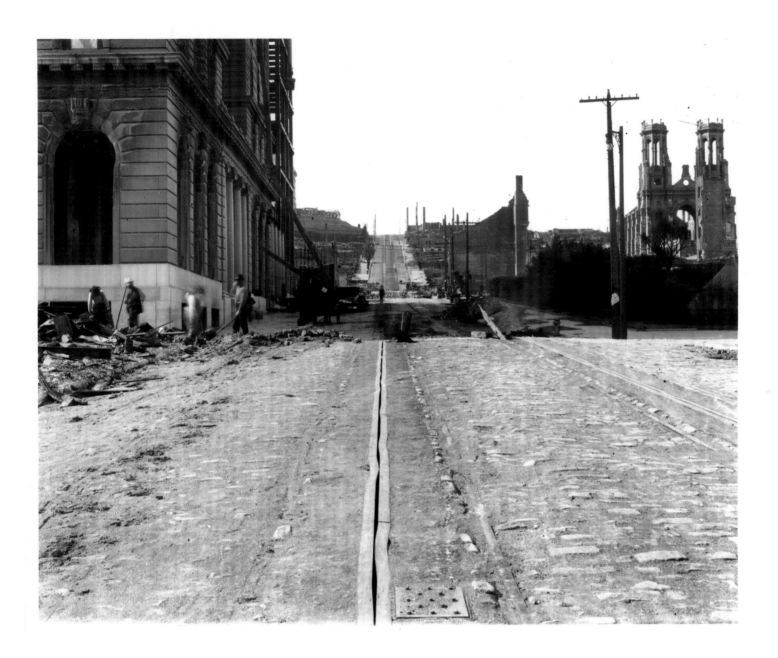

"WAITING HOTEL VAN, CORNER OF STOCKTON AND GEARY STREETS," 2004.
UNTITLED, 1906.

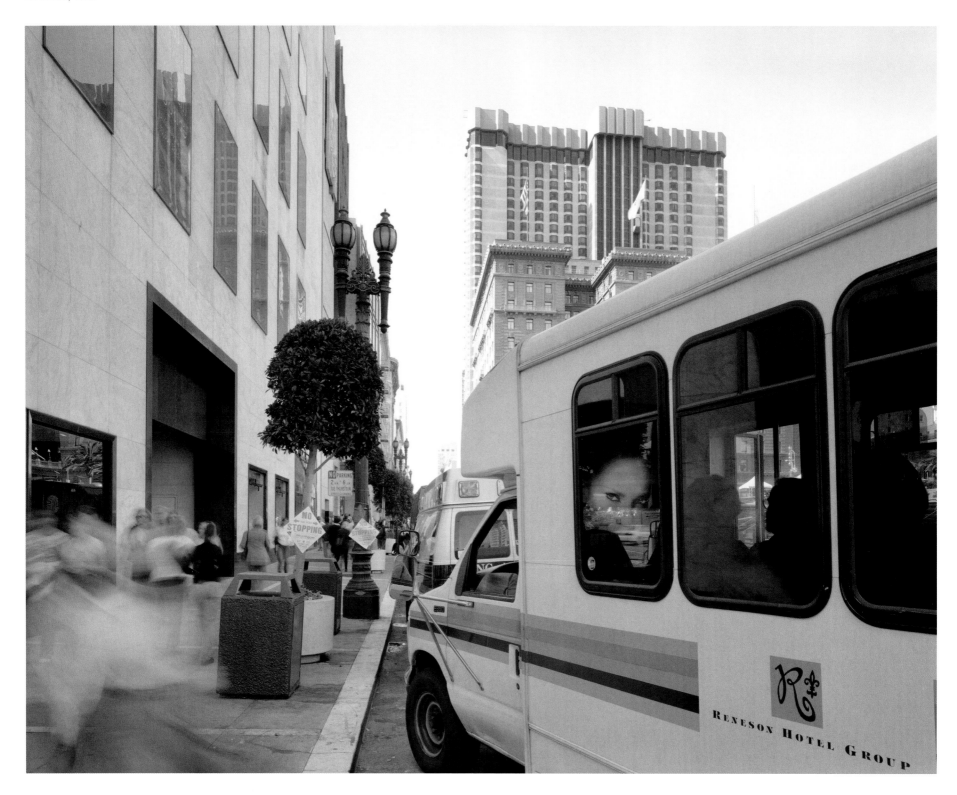

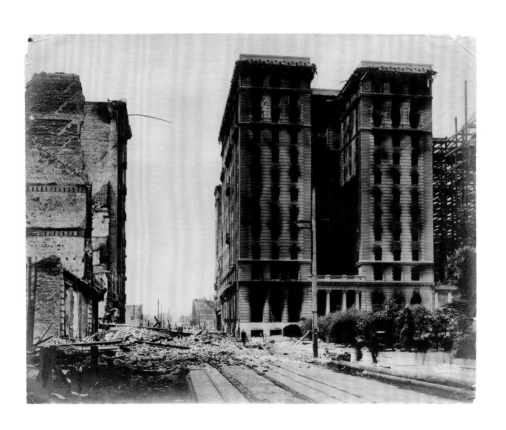

"LUNCH TIME, UNION SQUARE AND THE ST. FRANCIS HOTEL, LOOKING WEST," 2003.
UNTITLED, 1906.

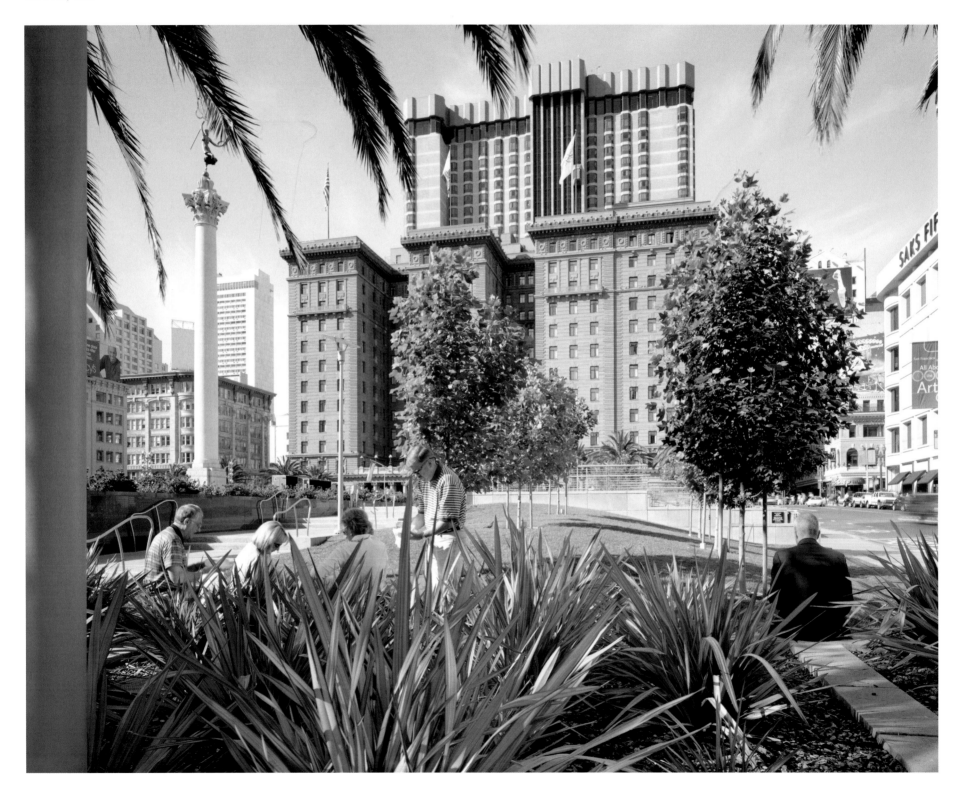

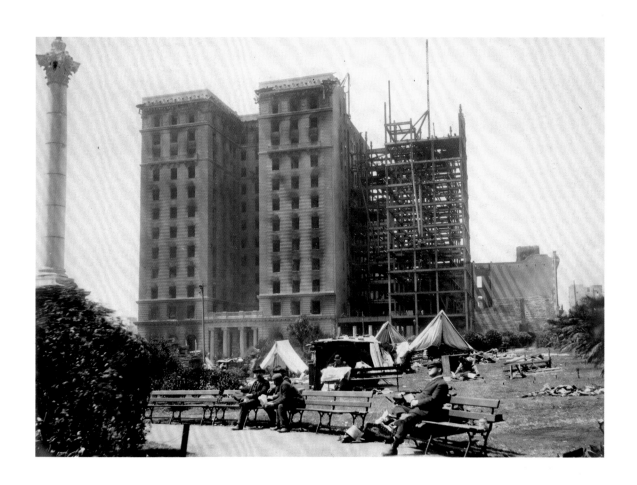

Plates 18A and 18B

"PANORAMA OF UNION SQUARE, WITH MENDENHALL'S 1906 VIEW EMBEDDED," 2003.
EMBEDDED, RIGHT: "BAGGAGE SALVAGED FROM THE ST. FRANCIS HOTEL, 1906."

Plates 19A and 19B

"DRINKING FOUNTAIN AT THE EAST END OF UNION SQUARE," 2004.
UNTITLED, 1906.

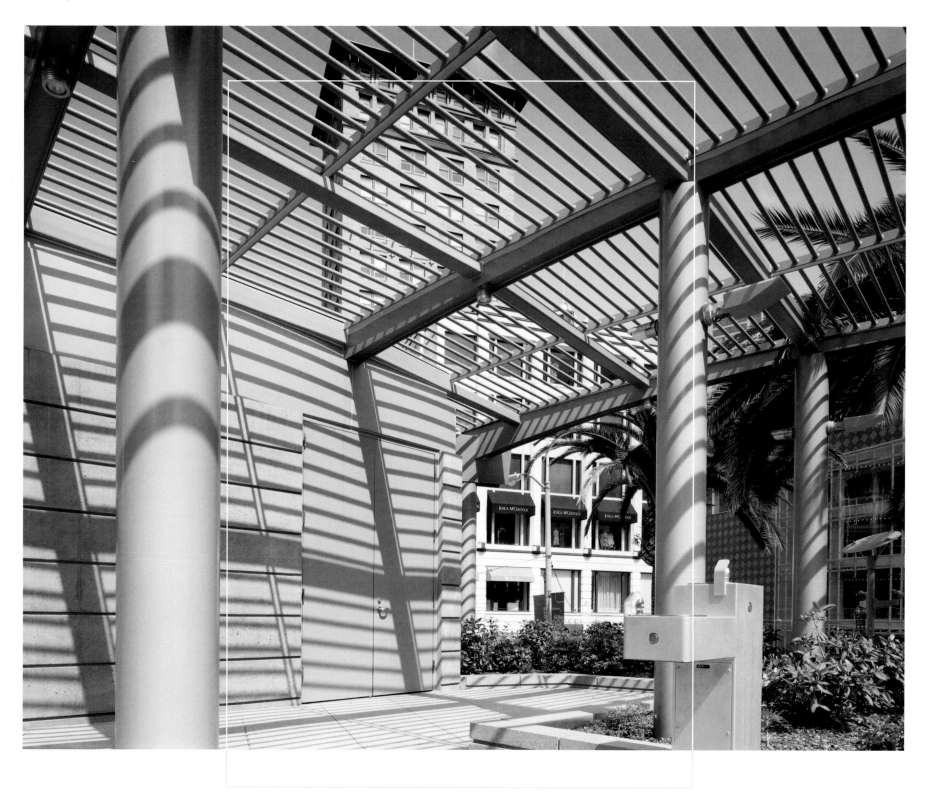

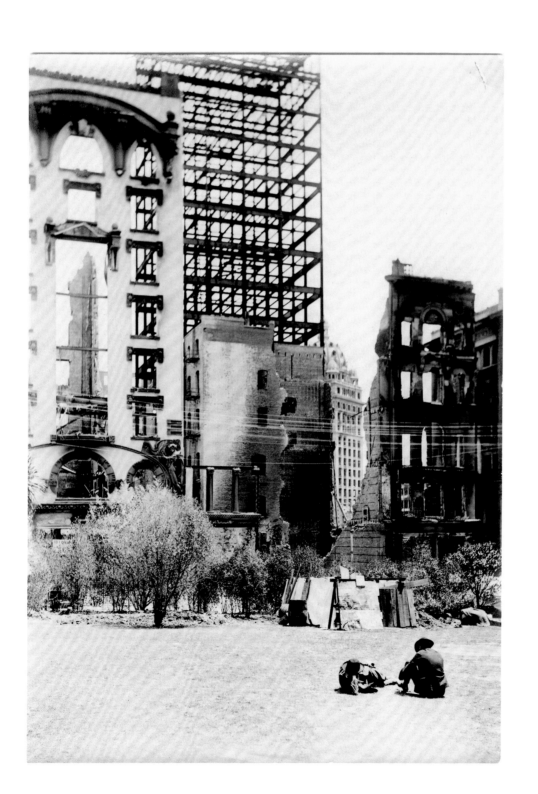

Plates 20A and 20B

"POST AND STOCKTON FROM THE RIGHT TURN LANE," 2003.
"LOOKING DOWN POST ST., PILES OF BRICKS CLEANED OFF AND READY TO BE RE-USED. SHREVE BUILDING, CORNER OF GRANT AND POST," 1907.

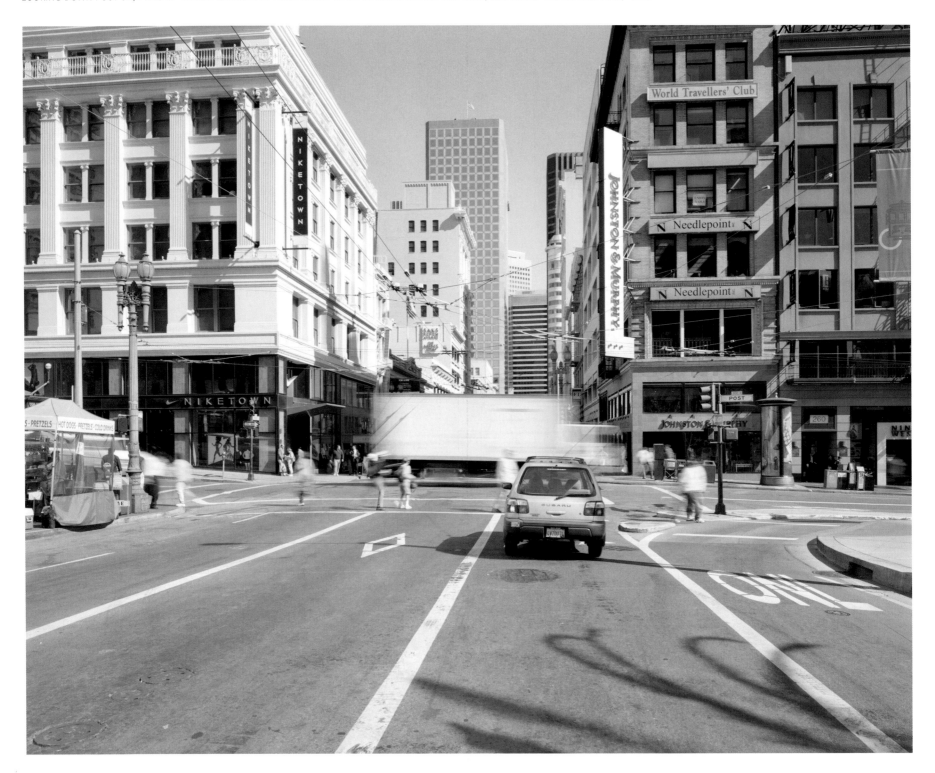

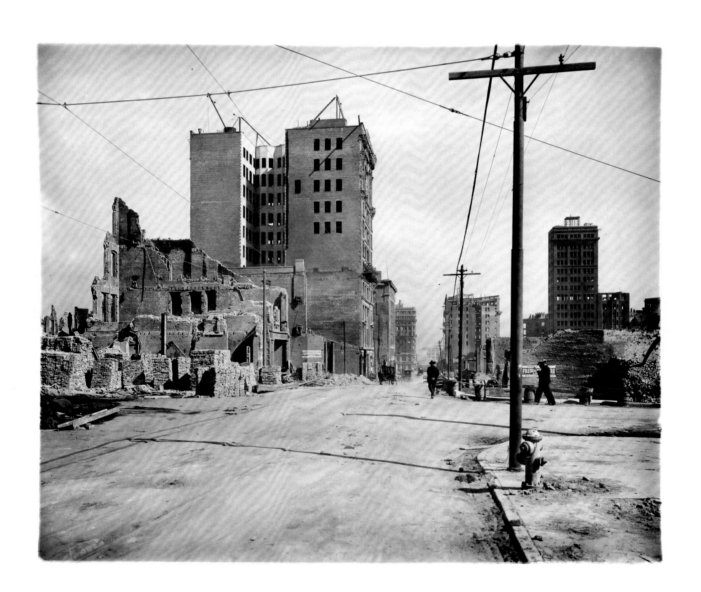

Plates 21A and 21B

"MOVING VAN, SACRAMENTO STREET NEAR POWELL," 2003.
UNTITLED (VIEW OF FIRE DOWN SACRAMENTO STREET), 1906.

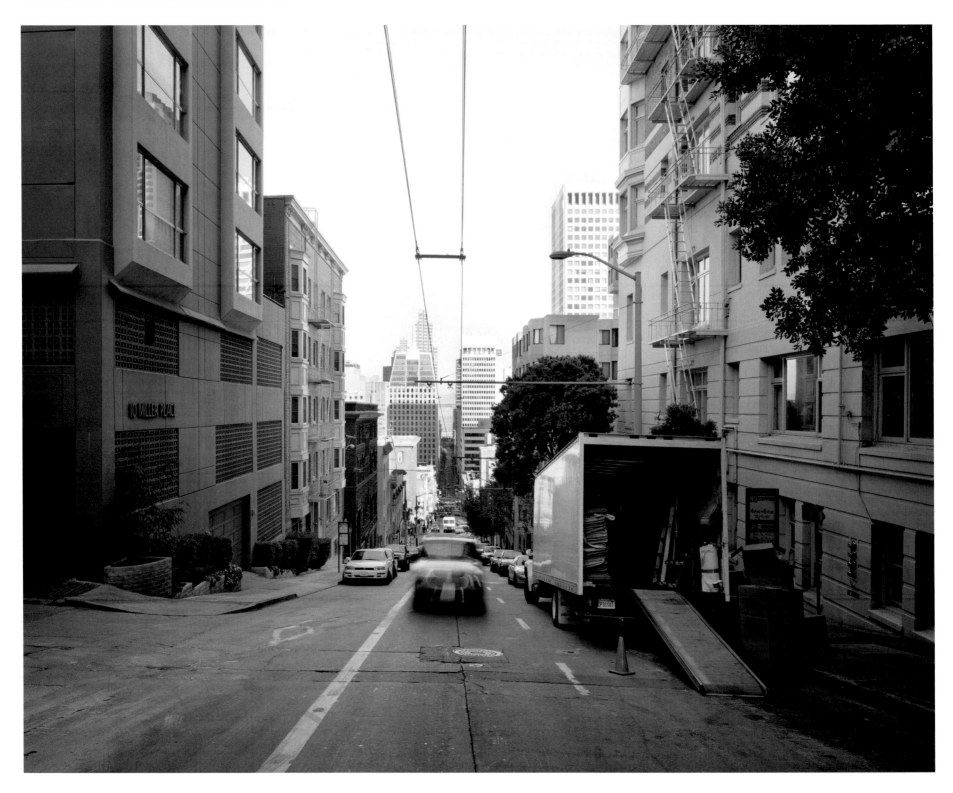

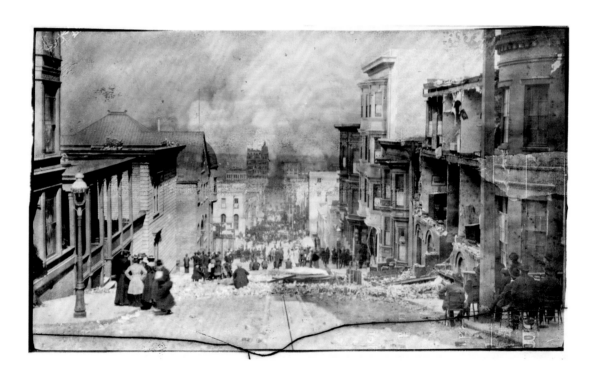

Plates 22A and 22B

"CLAY STREET NEAR OLD CHINATOWN," 2003.
UNTITLED (BURNING SAN FRANCISCO, LOOKING TO THE EAST FROM CLAY STREET), 1906.

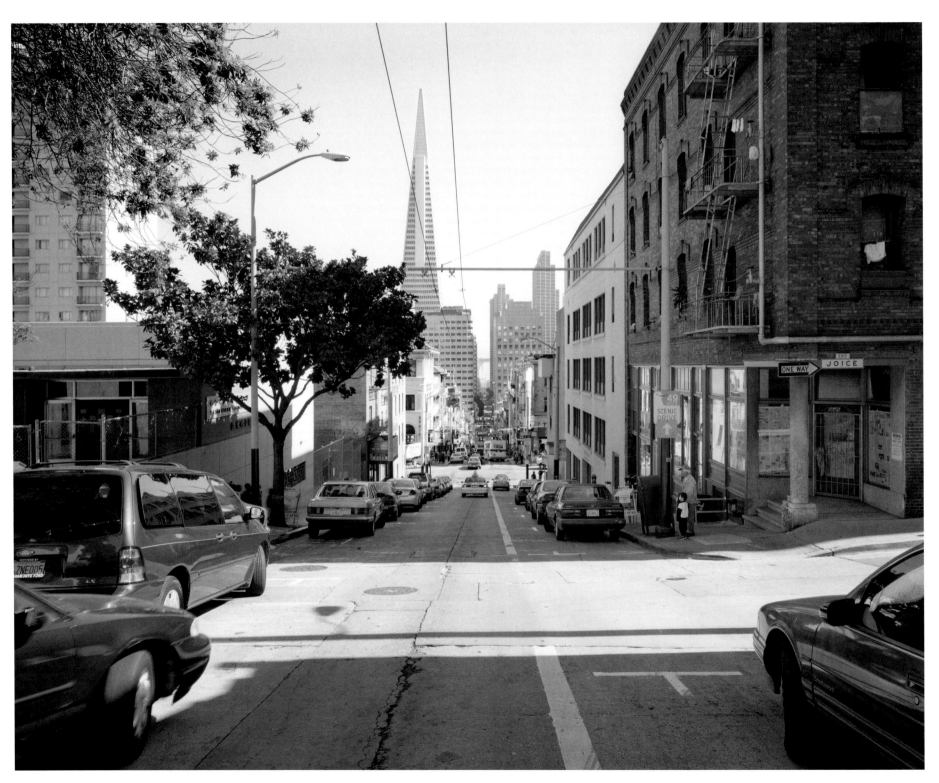

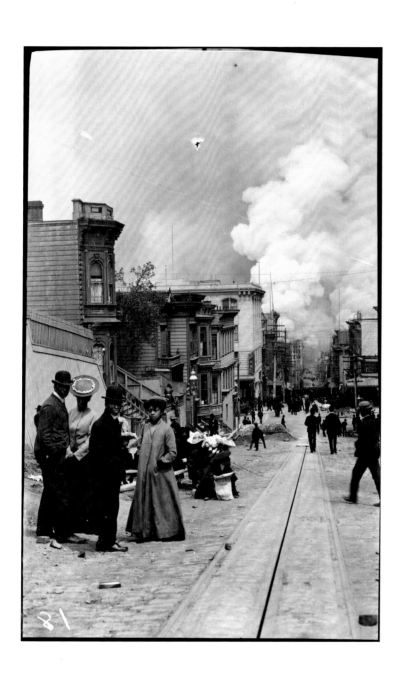

Plates 23A and 23B

"DOLORES PARK," 2004.
"FROM THE OLD JEWISH CEMETERY, 18TH AND DOLORES STREETS. THE MORNING OF THE GREAT EARTHQUAKE AND FIRE, APRIL 18TH, 1906. THE MISSION
 HIGH SCHOOL IS IN THE CENTER. SEE THE HOME OPPOSITE THE SCHOOL THE UNDER PINNINGS HAVE GIVEN AWAY *[SIC]*."

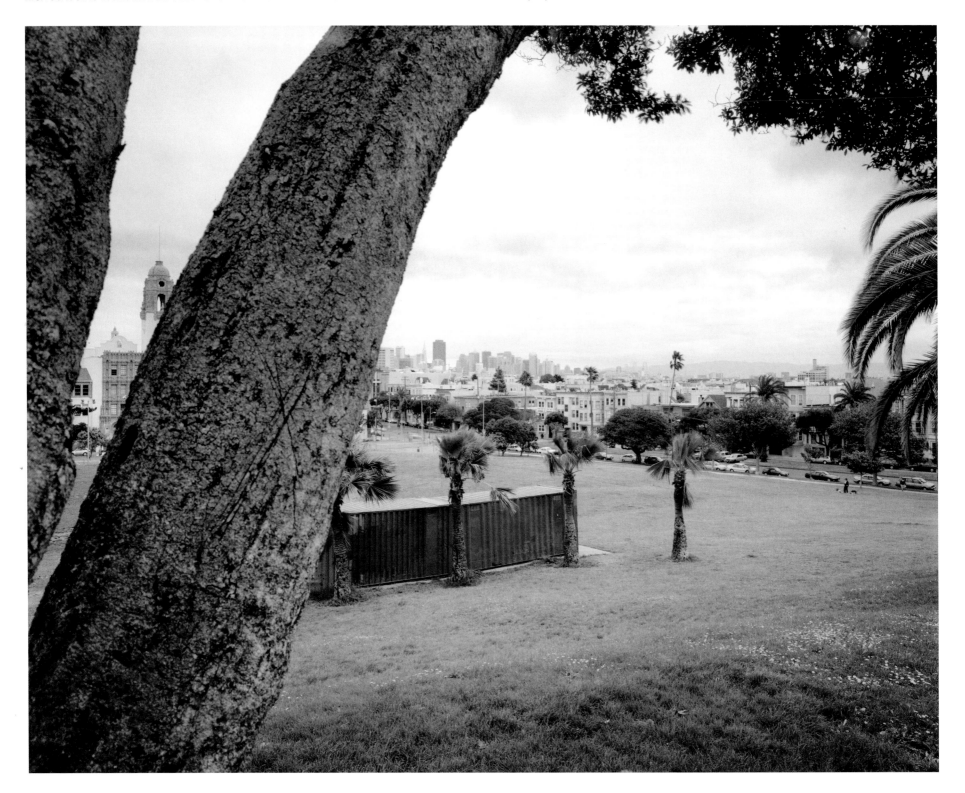

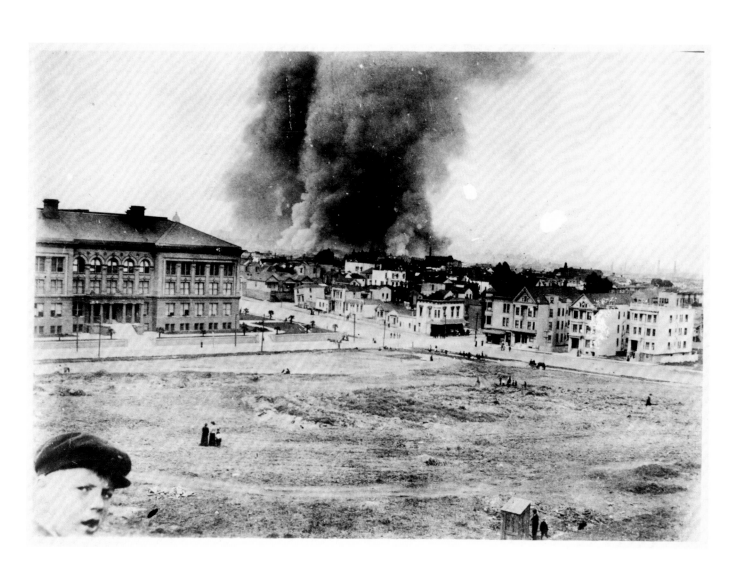

"THE EDGE OF LAFAYETTE PARK," 2003.
"LAFAYETTE SQUARE AT DUSK," 1906.

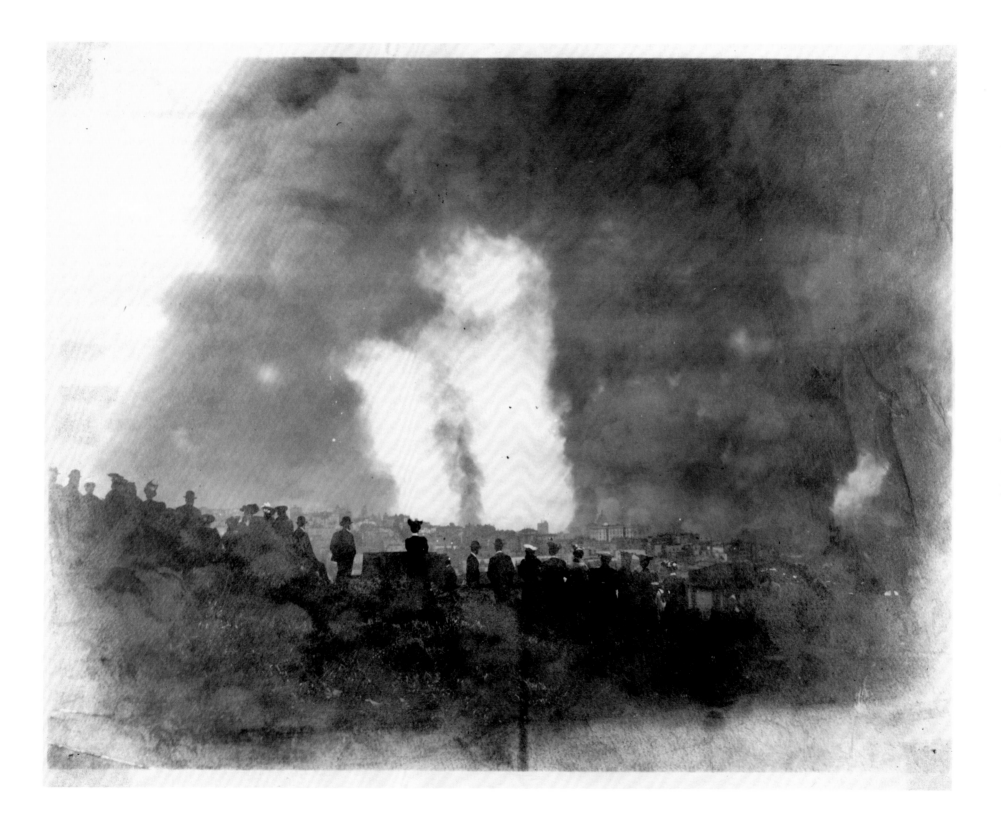

"STEPS, 821 LEAVENWORTH," 2003.

"STAIRS THAT LEAD TO NOWHERE (AFTER THE FIRE)," 1906.

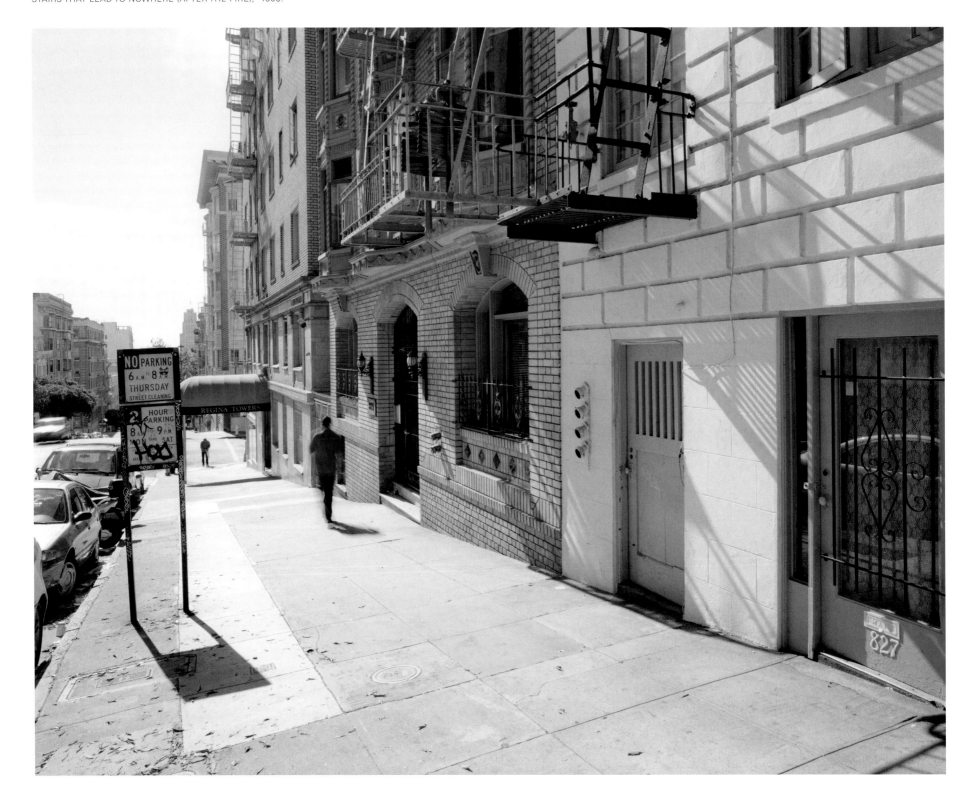

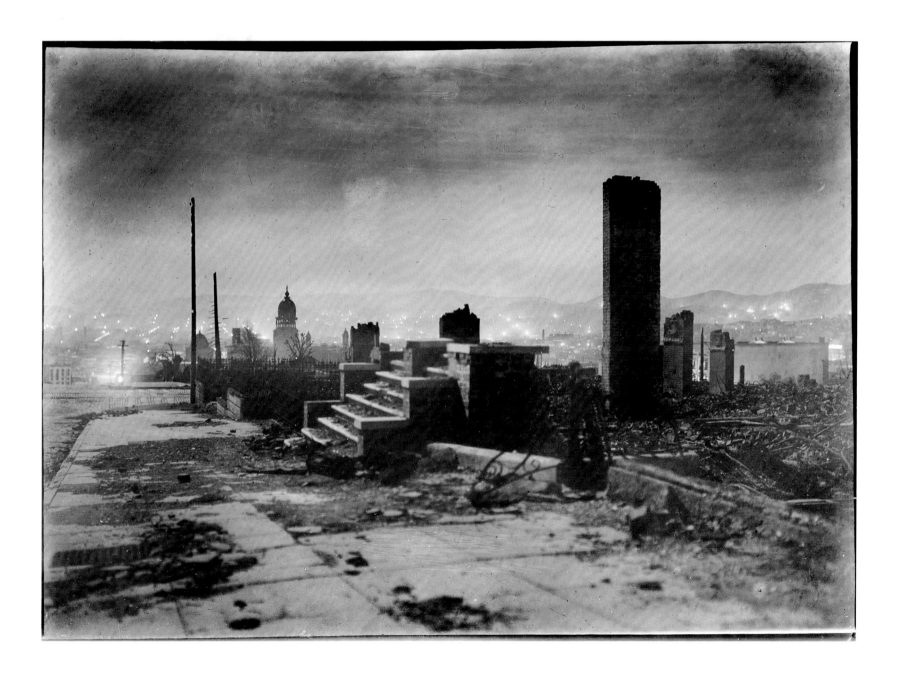

"VIEW EAST FROM THE VIEW TOWER APARTMENT BUILDING, RUSSIAN HILL," 2004.
"TELEGRAPH HILL AND NORTH BEACH, WIPED OUT BY FIRE. AROUND LOMBARD AND TAYLOR STS," 1906.

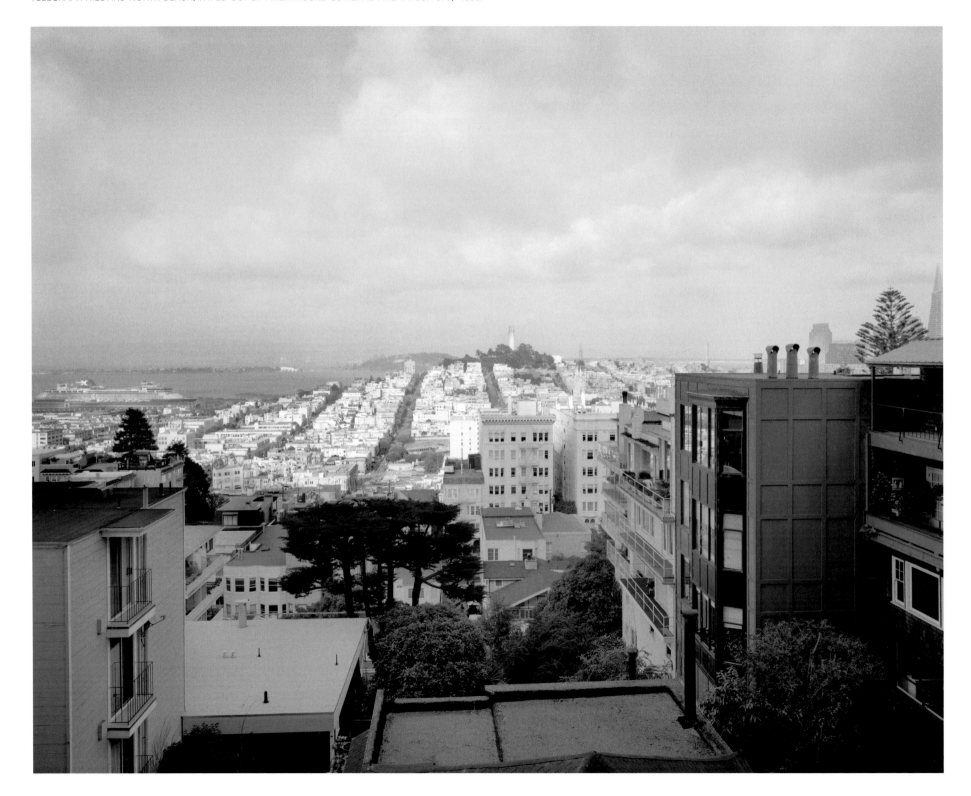

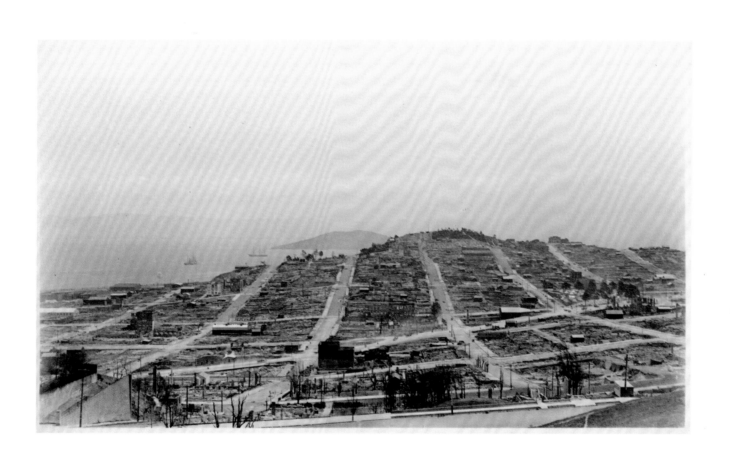

"VIEW SOUTH FROM ALTA PLAZA PARK," 2003.
"LOOKING SOUTH ON PIERCE ST. FROM ALTA PLAZA, RUINS OF ST. DOMINIC'S CHURCH," 1906.

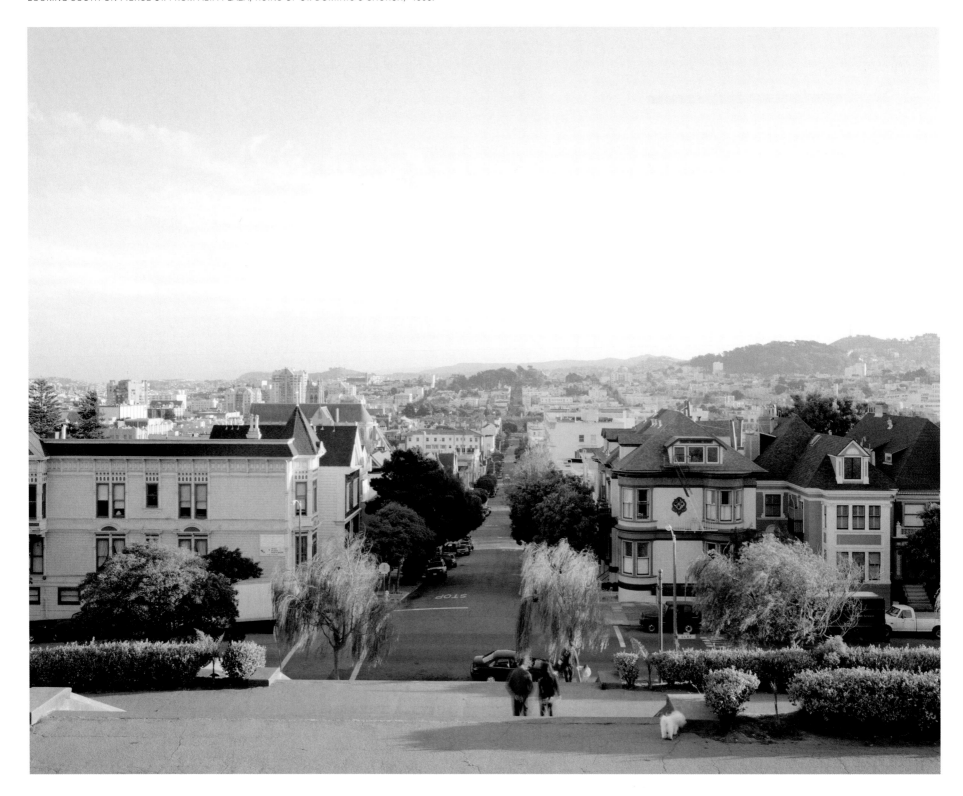

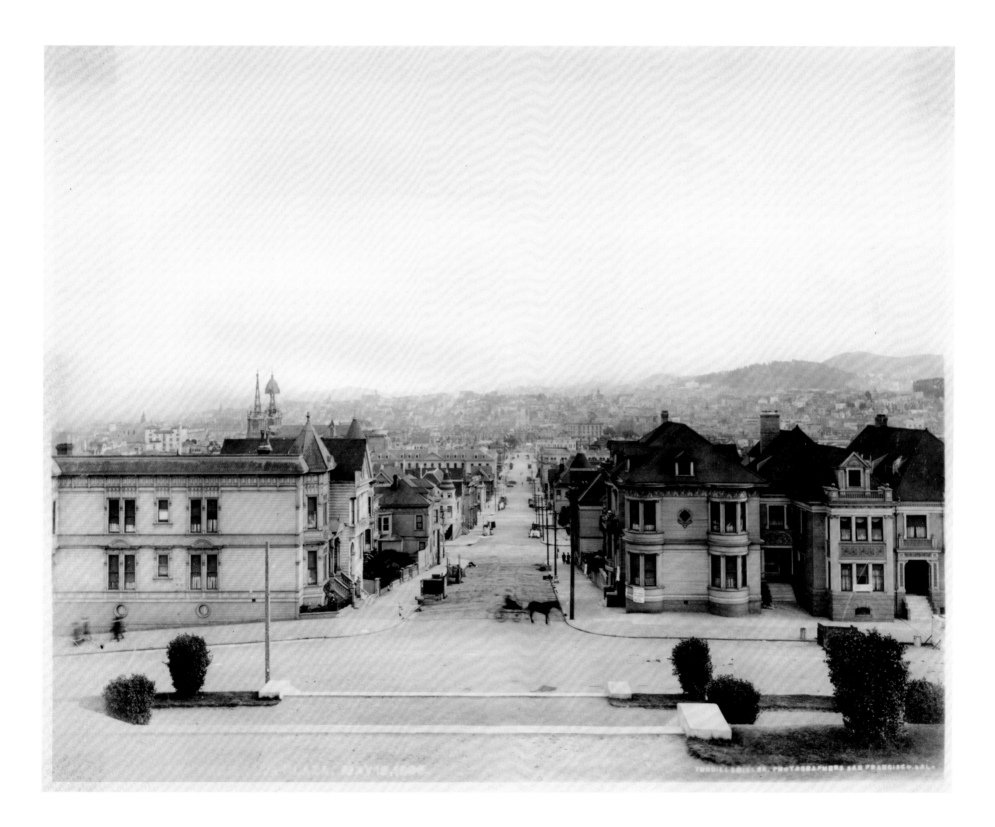

"HOME AT 2020 JACKSON STREET," 2003.
UNTITLED (E. S. HELLER HOME, 2020 JACKSON STREET), 1906.

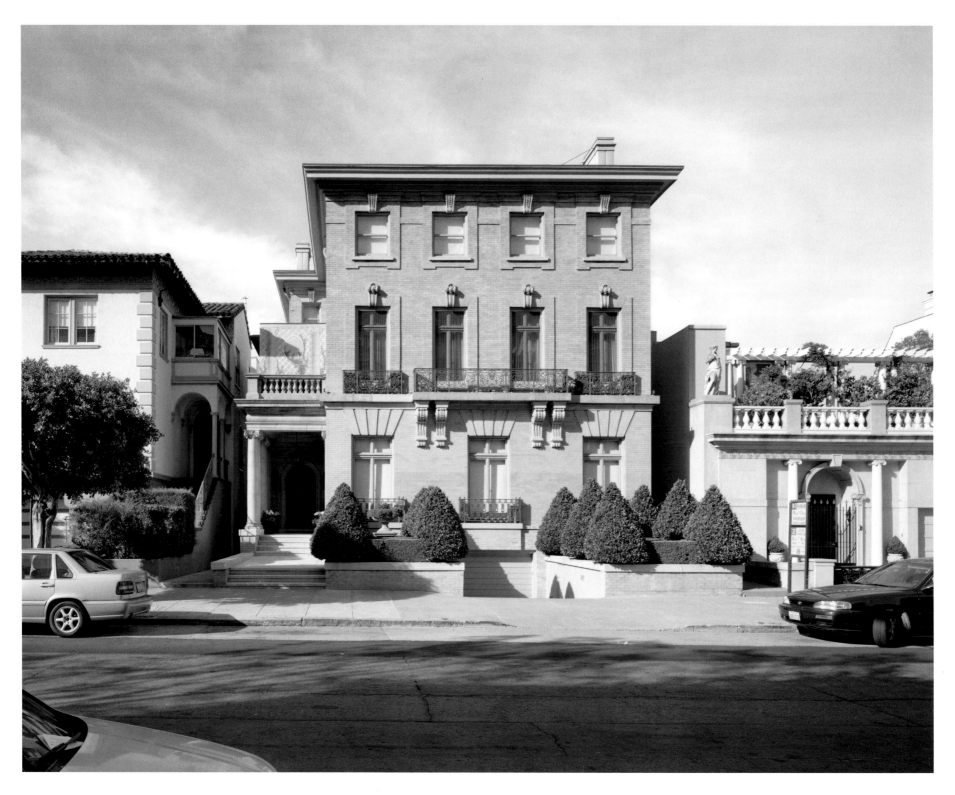

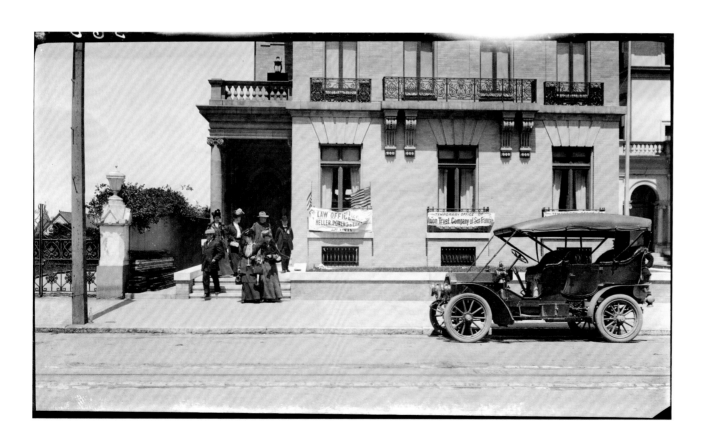

"SIDEWALK AT 2360 UNION STREET
NEAR PIERCE," 2004.

UNTITLED (EARTH SLIP ON
SAN FRANCISCO'S UNION STREET), 1906.

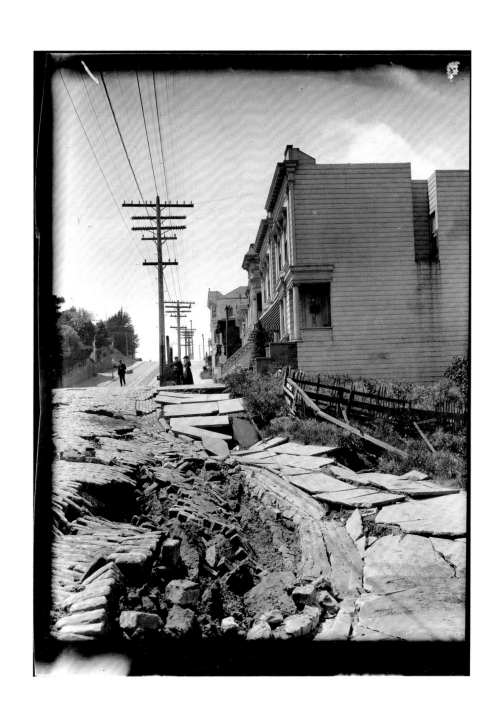

"SOUTH VAN NESS AT SEVENTEENTH STREET," 2003.
"HOWARD ST. BETWEEN 17TH AND 18TH," 1906.

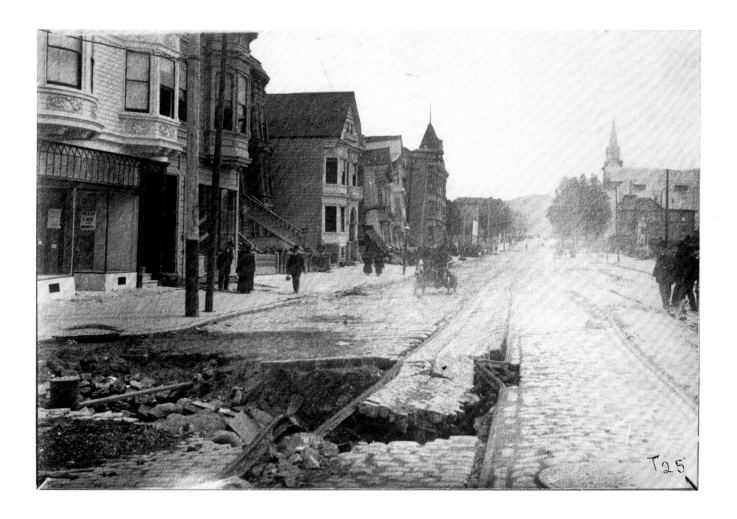

Plates 31A and 31B

"DRUGSTORE, CORNER OF BUSH AND FILLMORE STREETS," 2004.
UNTITLED (CORNER OF BUSH AND FILLMORE STREETS WITH ST. DOMINIC'S IN THE REAR), 1906.

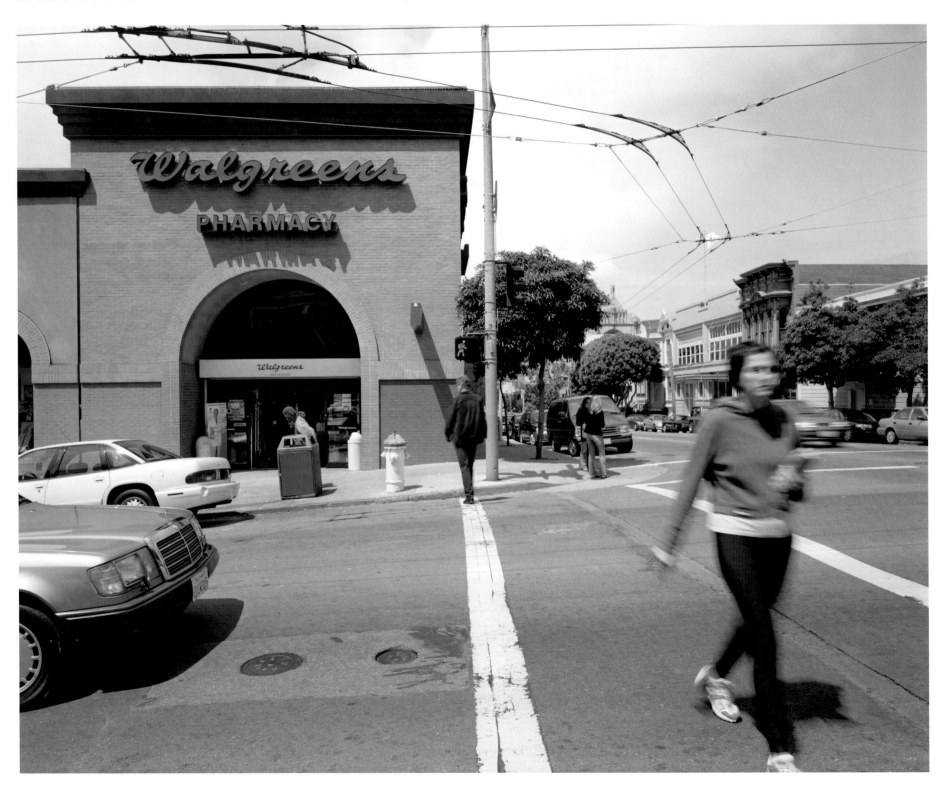

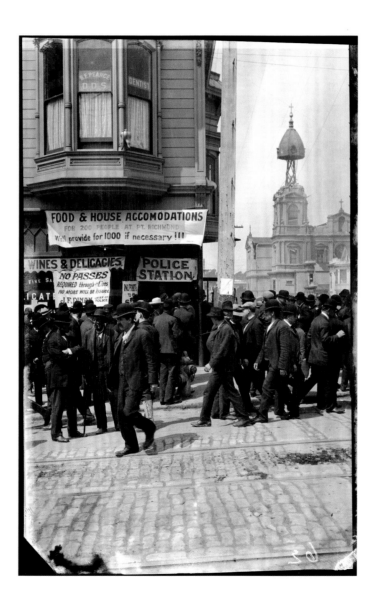

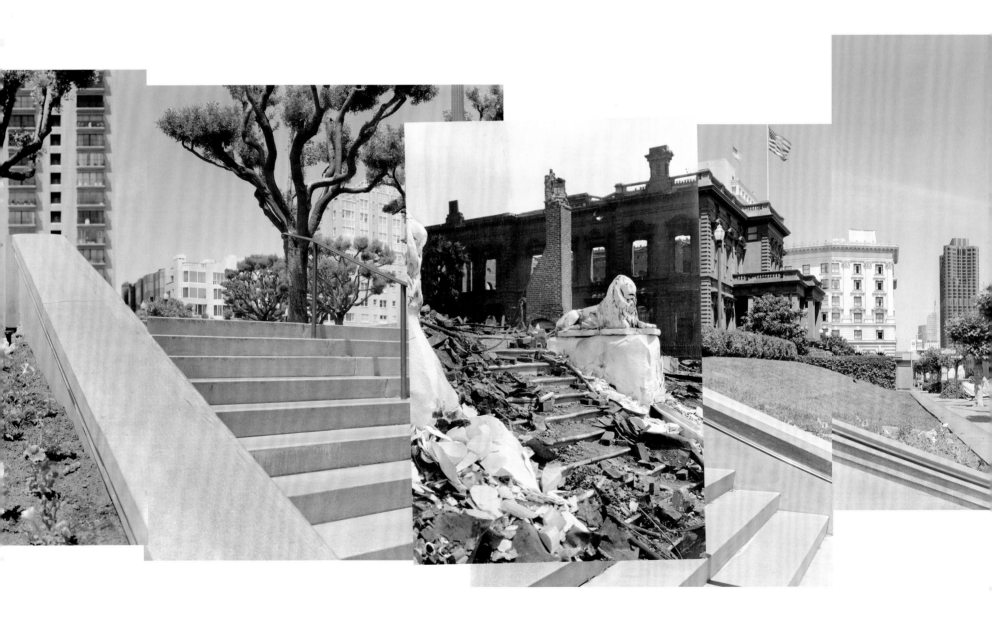

"PANORAMA OF NOB HILL FROM THE STEPS OF HUNTINGTON PARK, WITH GENTHE'S 1906 VIEW EMBEDDED," 2004.
EMBEDDED, LEFT: UNTITLED (SHATTERED STONE LION WHICH DECORATED A STAIRWAY IN PRE–FIRE AND EARTHQUAKE DAYS), 1906.

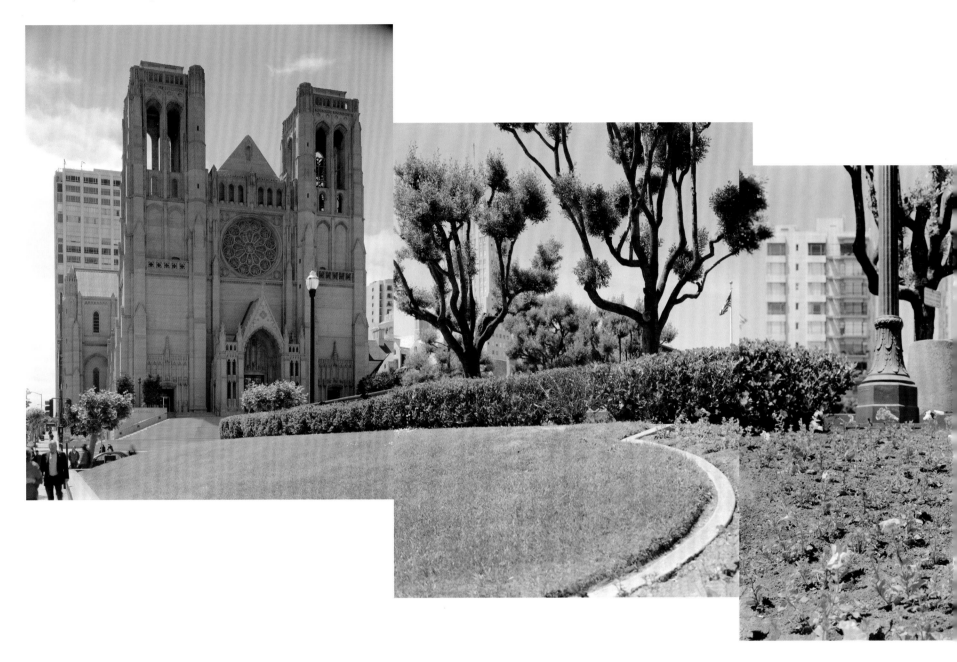

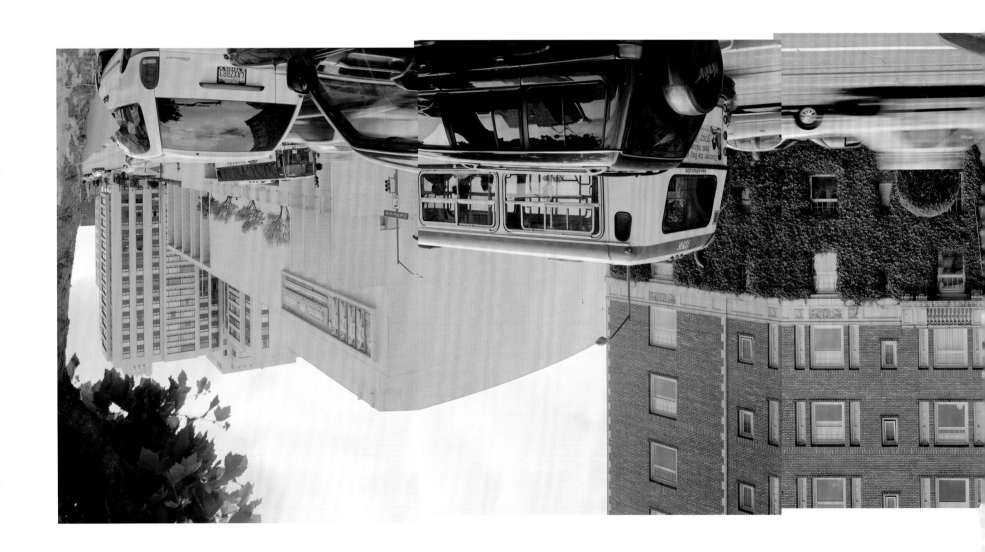

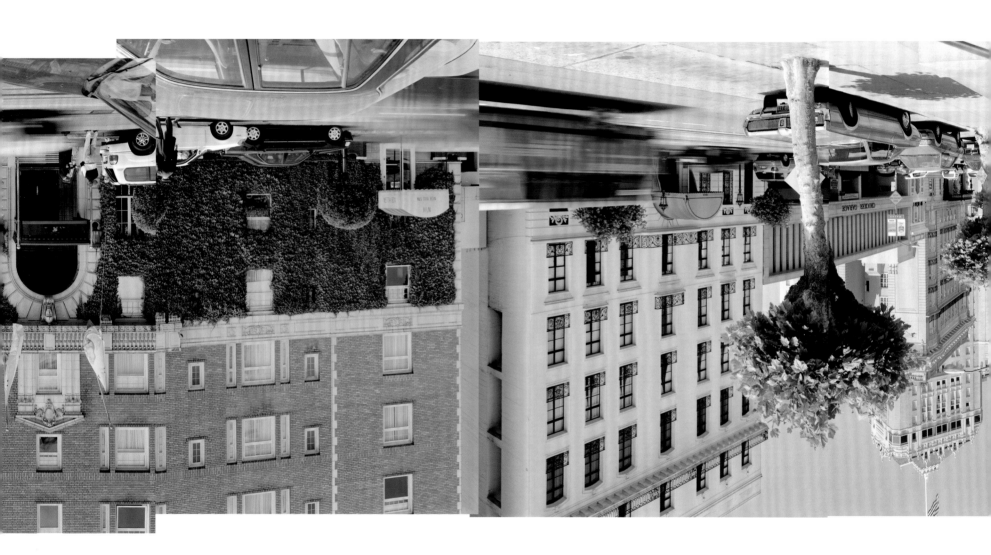

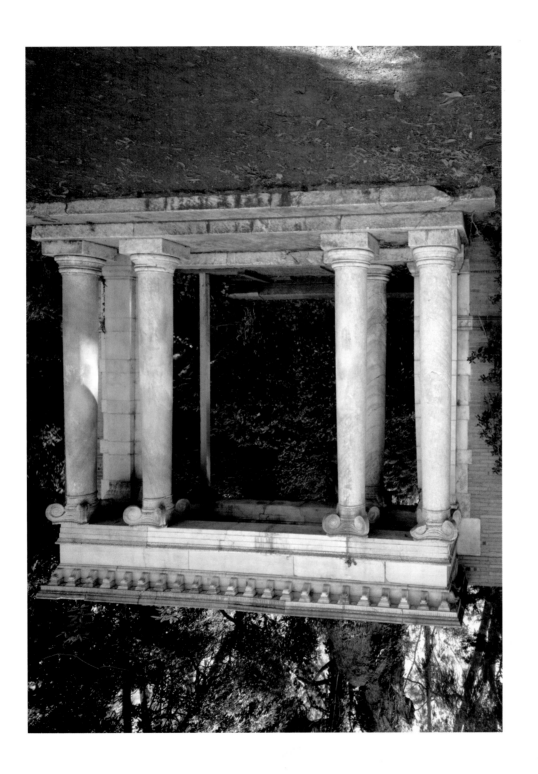

Plates 33A and 33B

"PORTALS OF THE PAST, FRONTAL VIEW,
GOLDEN GATE PARK," 2003.

UNTITLED (VIEW OF DEVASTATED SAN FRANCISCO,
FRAMED BETWEEN REMAINING PORTALS OF
TOWNE MANSION ON NOB HILL), 1906.

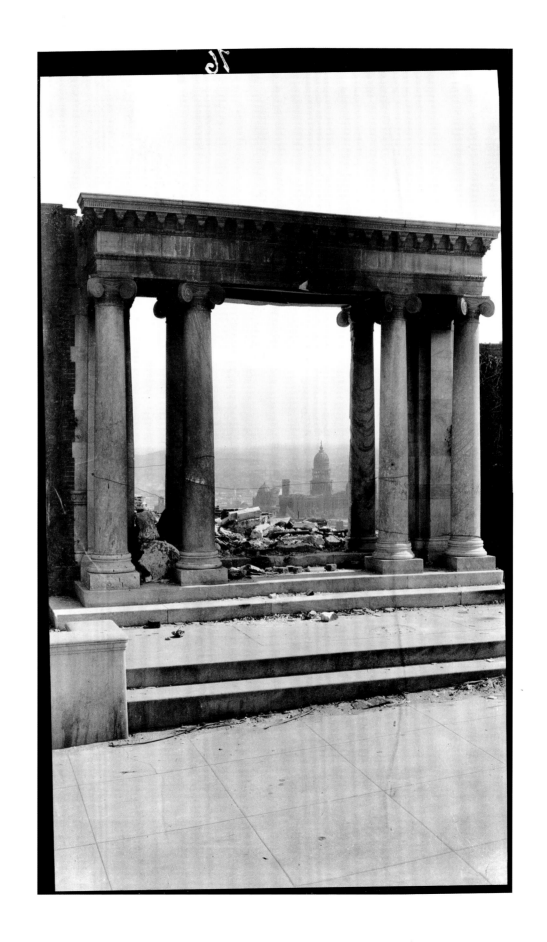

Plates 34A and 34B

"PORTICO OF THE TOWNE MANSION, MOVED TO LLOYD LAKE, GOLDEN GATE PARK," 2003.
"A. N. TOWNE RESIDENCE, VIEW FROM THE CHAS. CROCKER RESIDENCE—CALIFORNIA STREET," CA. 1905.

WILLIAM N. TOWNE RESIDENCE.

VIEW FROM THE CHAS. CROCKER RESIDENCE—CALIFORNIA STREET.

"GRACE CATHEDRAL, CALIFORNIA AND JONES STREETS," 2003.
"NORTH SIDE CALIFORNIA ST. FROM JONES ST., FEB. 7, 1907. HENRY CROCKER HOME RUINS. GRACE CATHEDRAL EMBRYO."

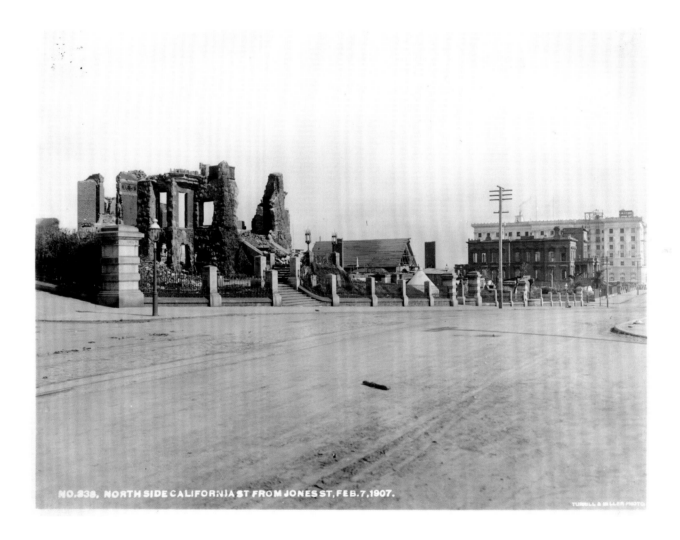

NO. 838, NORTH SIDE CALIFORNIA ST. FROM JONES ST., FEB. 7, 1907.

TURRILL & MILLER PHOTO

"PORTSMOUTH SQUARE," 2003.
UNTITLED (NORTHWEST FROM KEARNY THROUGH PORTSMOUTH SQUARE), 1906.

"MISSION DOLORES," 2003.
"DOLORES MISSION, SW CORNER OF 16TH AND DOLORES ST.," 1906.

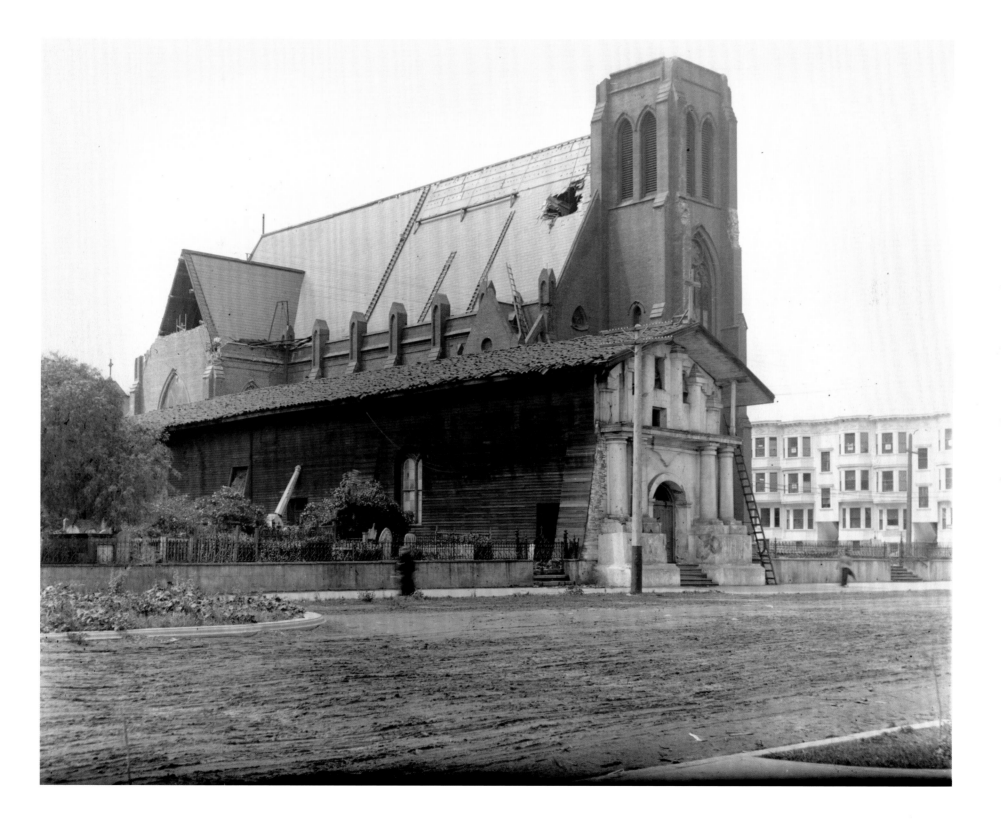

Plates 38A and 38B

"JEFFERSON SQUARE WITH THE STEEPLE OF ST. MARK'S LUTHERAN CHURCH [AT THE RIGHT]," 2003.
UNTITLED (EARTHQUAKE REFUGEE CAMP IN PARK), 1906.

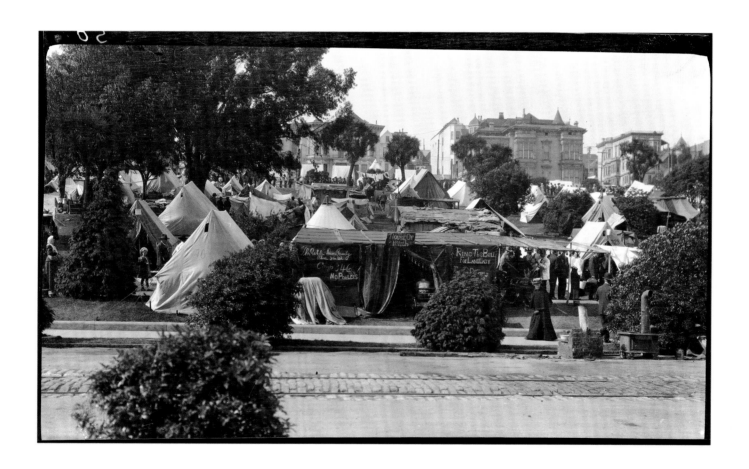

"BALL FIELD, MOSCONE RECREATION CENTER," 2004.
"CAMP 8, LOBOS SQUARE," 1906.

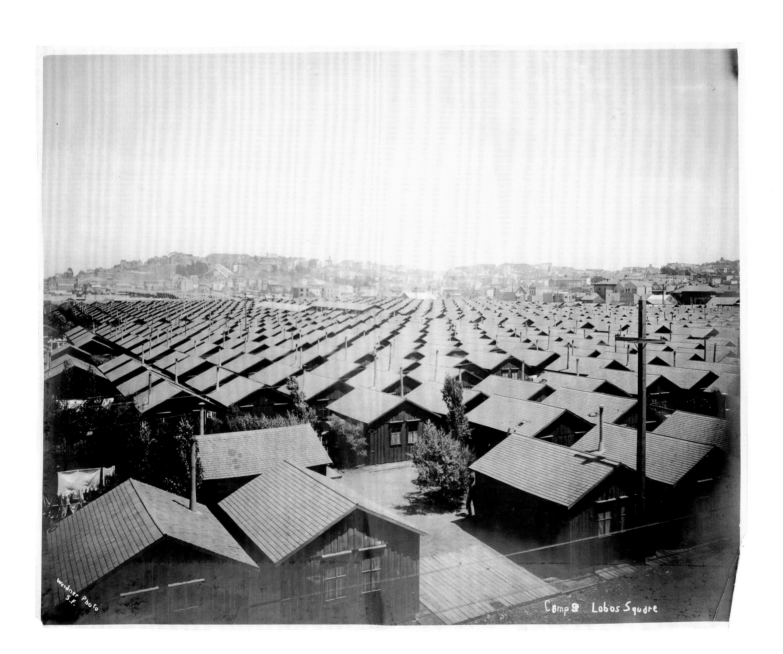

Camp & Lobos Square

weidner Photo
S.F.

"FORMER REFUGEE CAMP, NOW A PLAYGROUND, THE PRESIDIO," 2003.
UNTITLED (WOMAN GREETS MOUNTED SOLDIER IN THE PRESIDIO IN POST FIRE AND EARTHQUAKE), 1906.

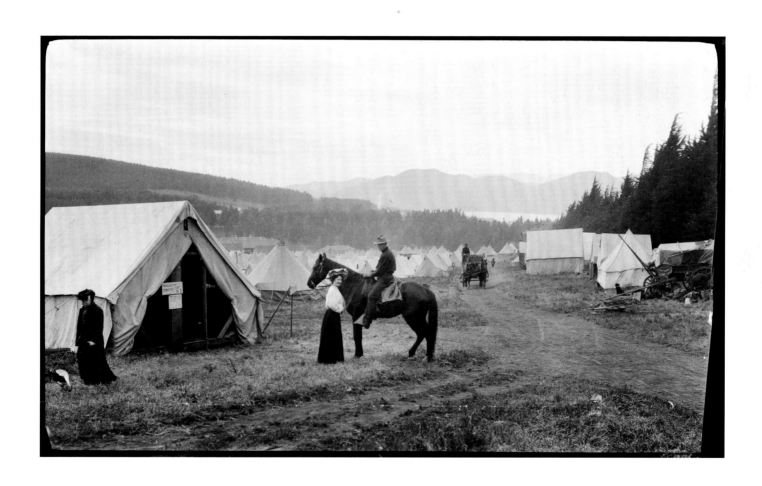

"CAROUSEL, GOLDEN GATE PARK," 2003.
"CHILDREN'S PLAYGROUND GG PARK," 1906.

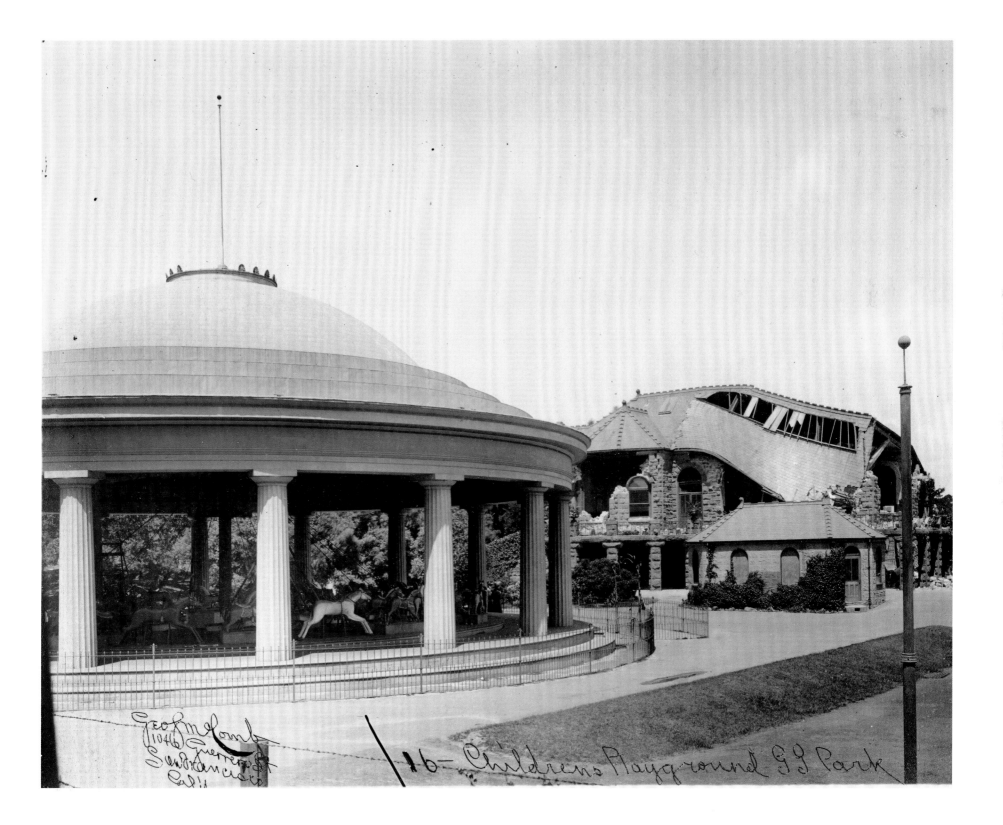

Geo Lombi
1046 Guerrero St
San Francisco
Cal.

116 - Childrens Playground G G Park

"THE BAND SHELL AND THE EDGE OF THE CONSTRUCTION ZONE FOR THE NEW DE YOUNG MUSEUM, GOLDEN GATE PARK," 2004.
"BAND STAND IN GOLDEN GATE PARK," 1906.

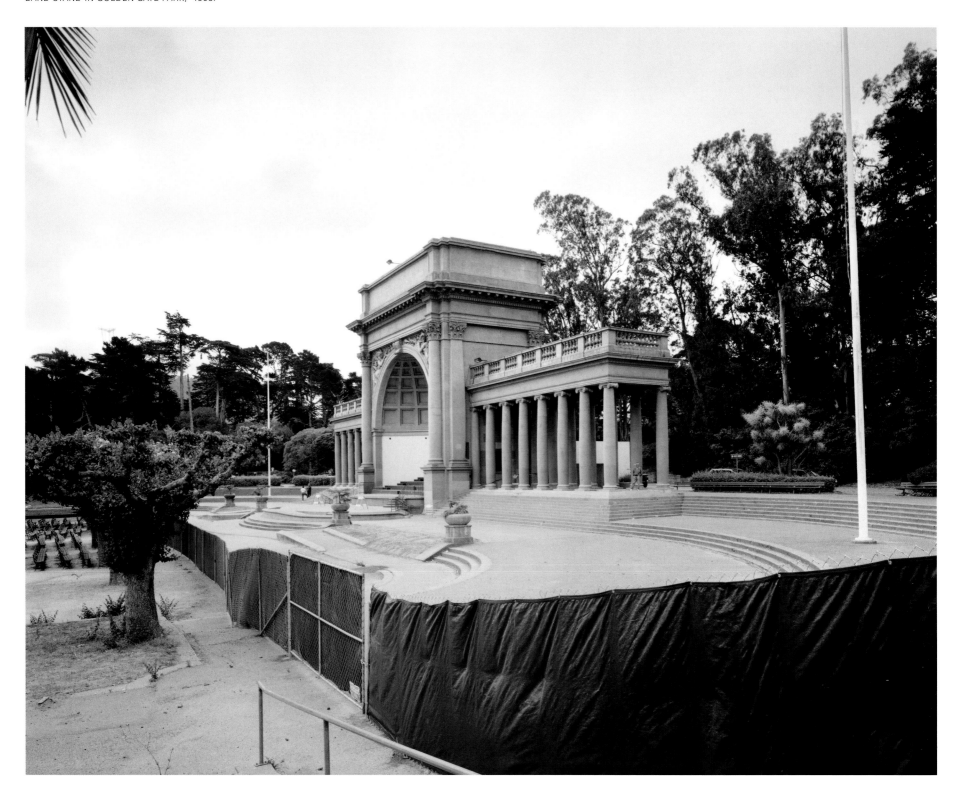

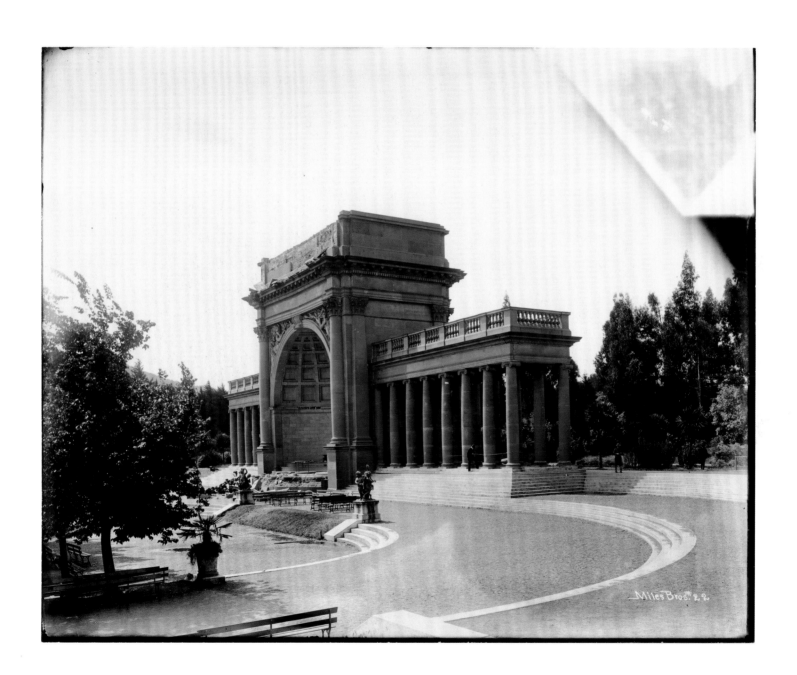

Miles Bros. 2.2.

"INTERIOR OF THE STANFORD UNIVERSITY CHAPEL," 2004.
UNTITLED, 1906.

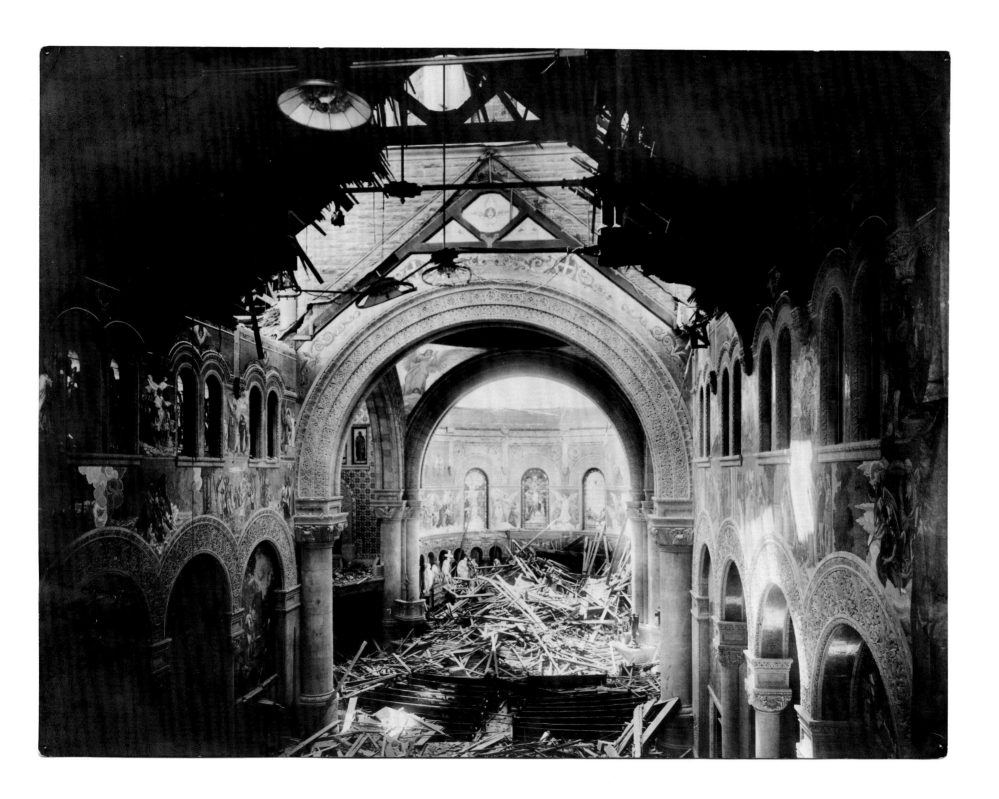

"WALKWAY, STANFORD UNIVERSITY," 2003.
"AGASSIZ STATUE AT STANFORD, APRIL, 1906."

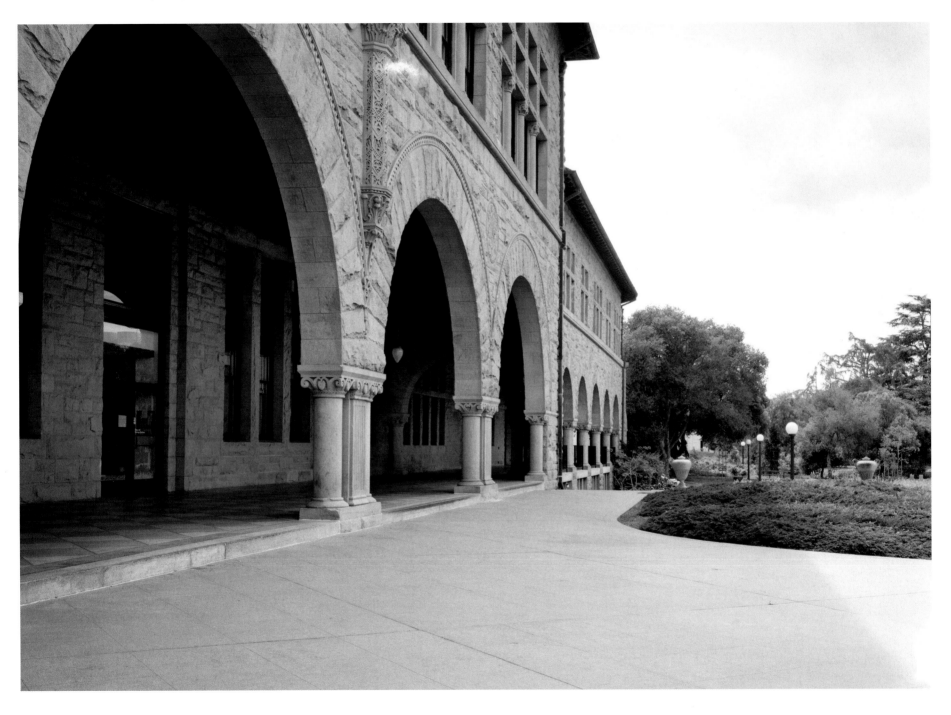

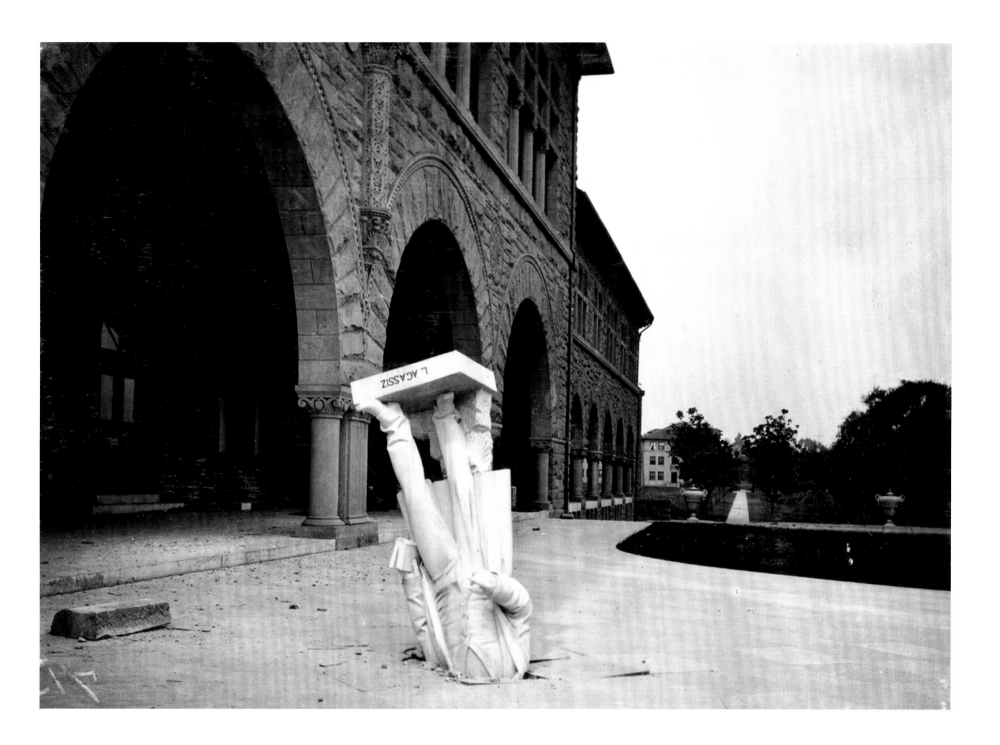

Plates 45A and 45B

"RIGHTED MONUMENT,
HOLY CROSS CEMETERY," 2003.

"OVERTHROWN MONUMENT," 1906.

"BARN AT THE HEADQUARTERS OF POINT REYES NATIONAL SEASHORE," 2003.
"SOUTHEAST CORNER OF BARN MOVED NORTHWEST TO ITS PRESENT LOCATION, FROM POST ON MAN'S FOOT," 1906.

"REBUILT CHURCH, FORT ROSS STATE HISTORIC PARK," 2004.
"OLD RUSSIAN CHURCH, FT ROSS—AFTER," 1906.

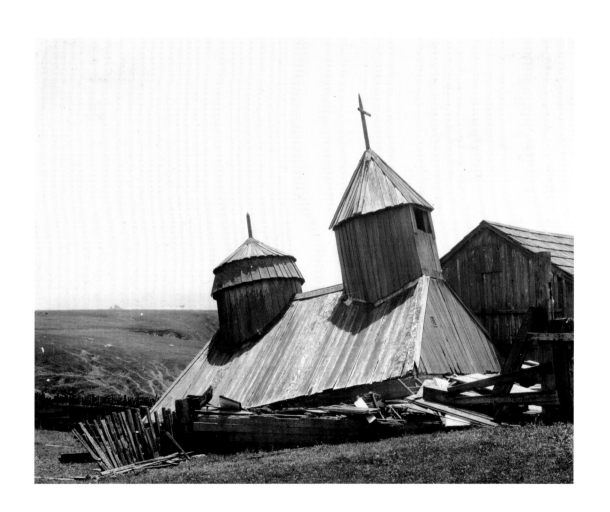

"OAK TREE IN COVERED FAULT LINE, POINT REYES NATIONAL SEASHORE," 2003.
"FAULT TRACE 2 MILES NORTH OF THE SKINNER RANCH AT OLEMA. VIEW IS NORTH," 1906.

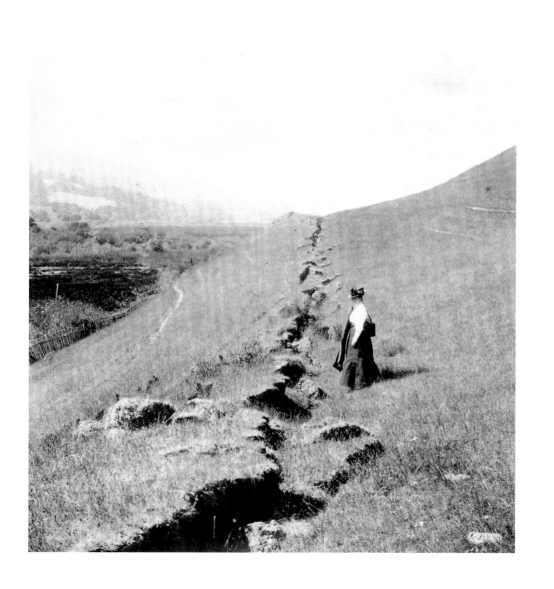

MAPS OF PHOTOGRAPH LOCATIONS

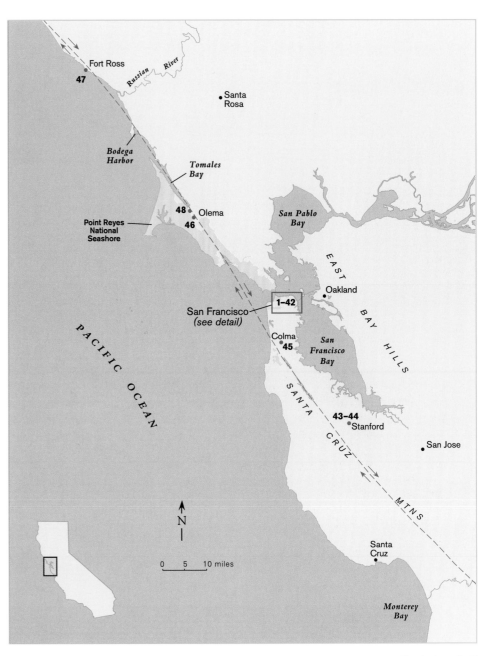

The numbers on the maps correspond to the plate numbers used in this book. On the area map (this page), the red dots locate the cities in which the photographs were taken. On the San Francisco detail map (opposite), the red dots locate the vantage points from which each contemporary photograph was taken.

- - - - San Andreas Fault

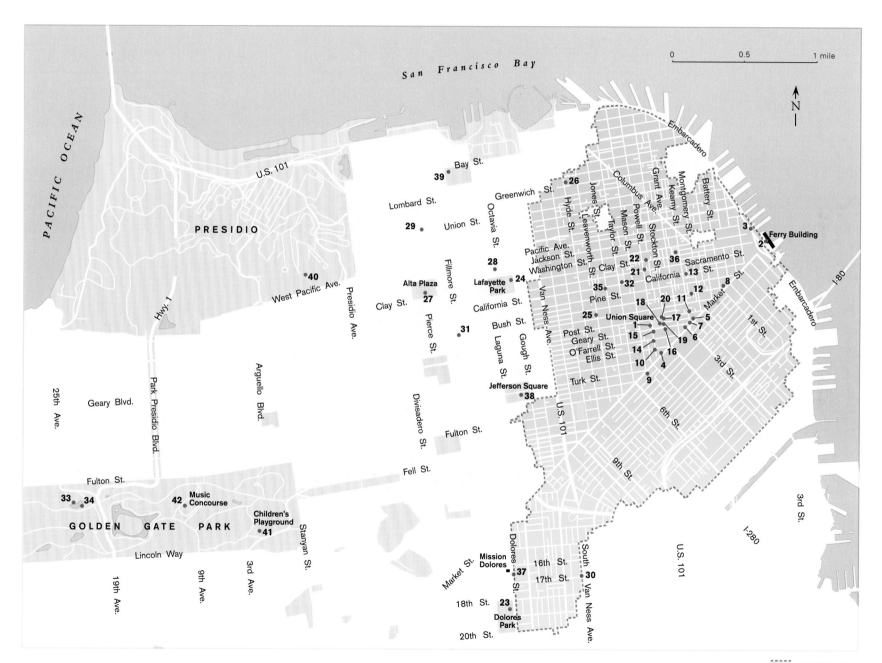

San Francisco Bay

PACIFIC OCEAN

PRESIDIO

0 0.5 1 mile

N

Embarcadero

U.S. 101

39 Bay St.

26

Greenwich St.

Columbus Ave.

Grant Ave.

Montgomery St.

Battery St.

3

Ferry Building

Lombard St.

Octavia St.

Kearny St.

29 Union St.

Hyde St.

Jones St.

Leavenworth St.

Taylor St.

Mason St.

Powell St.

Stockton St.

2

Pacific Ave.

Jackson St.

Washington St.

Clay St.

22

36

Sacramento St.

28

13 St.

West Pacific Ave.

Presidio Ave.

40

Alta Plaza

24

21

California

8 St.

35

32

12

Lafayette Park

Clay St.

27

Fillmore St.

California St.

Pine St.

18

20 **11**

Market

31

Bush St.

25

Union Square

17

5

Pierce St.

Laguna St.

Gough St.

Van Ness Ave.

Post St.

1

19 **6**

7

Geary St.

15

1st St.

O'Farrell St.

14

16

Jefferson Square

Ellis St.

10

4

3rd St.

38

Turk St.

9

Divisadero St.

Fulton St.

U.S. 101

6th St.

I-80

Embarcadero

Fell St.

9th St.

1st St.

3rd St.

Geary Blvd.

Park Presidio Blvd.

Arguello Blvd.

Fulton St.

I-280

25th Ave.

33 **34**

42 Music
Concourse

GOLDEN GATE PARK

Children's
Playground

41

Lincoln Way

19th Ave.

9th Ave.

3rd Ave.

Stanyan St.

U.S. 101

Market St.

Mission
Dolores

Dolores St.

16th St.

17th St.

South Van Ness Ave.

Van Ness Ave.

37

30

18th St.

23

Dolores
Park

20th St.

- - - - 1906 Fire Zone

PHOTOGRAPHS AND CREDITS

Page 5. "Mark Klett and Michael Lundgren rephotographing the Call Building, Market and Third Streets," 2003. Alex L. Fradkin. Silver gelatin print. Courtesy of Alex L. Fradkin.

Page 7. *See under* plates 13A and 13B.

Page 8. "The Ferry Building from the southwest, with palm trees," 2004. Mark Klett with Michael Lundgren.

Page 9. "Apartment building destroyed by fire, Kobe, Japan," 1995. Mark Klett.

Page 10. "Mark Klett rephotographing Grace Cathedral, California and Jones Streets," 2003. Alex L. Fradkin. Silver gelatin print. Courtesy of Alex L. Fradkin.

Page 13. Untitled (Charred Corpse in Street Amid Rubble and Ruin), 1906. Arnold Genthe. Gelatin silver print, 221 x 313 mm (8-3/4 x 12-5/16 in.). Fine Arts Museums of San Francisco, Museum Purchase, James D. Phelan Bequest Fund, A021293.

Page 16. Untitled (View above City Hall after Earthquake and Fire), 1906. Arnold Genthe. Gelatin silver print, 197 x 351 mm cropped (7-3/4 x 13-13/16 in.). Fine Arts Museums of San Francisco, Museum Purchase, James D. Phelan Bequest Fund, A021278.

Page 21. "Remnant of gun emplacement, Battery Mendell, Marin Headlands," 1988. Mark Klett.

Page 22. Portals of the Past. *Left:* "A. N. Towne Residence, View from the Chas. Crocker Residence—California Street," ca. 1905. Detail. Photographer unknown. The Bancroft Library, University of California, Berkeley. *Middle:* Untitled (View of devastated San Francisco, framed between remaining portals of Towne Mansion on Nob Hill), 1906. Arnold Genthe. Cellulose nitrate negative, 149 x 84 mm (5-7/8 x 3-5/16 in.) irreg. Fine Arts Museums of San Francisco, Museum Purchase, James D. Phelan Bequest Fund, A355879. *Right:* "Portico of the Towne mansion, moved to Lloyd Lake, Golden Gate Park," 2003. Detail. Mark Klett with Michael Lundgren.

Page 23. "Railroad House after the Earthquake 21st Oct. 1868" (one frame of stereograph). Eadweard Muybridge. The Bancroft Library, University of California, Berkeley.

Page 24. "Slum clearance," Western Addition, San Francisco, 1953. San Francisco History Center, San Francisco Public Library.

Page 26. "March of the Evicted," San Francisco anti-gentrification poster with image by Eric Drooker, 2000. Susan Schwartzenberg, from Solnit and Schwartzenberg, *Hollow City: The Siege of San Francisco and the Crisis of American Urbanism* (New York: Verso, 2000).

Page 27. "Gentrify Me!" Anti-gentrification poster by San Francisco Print Collective, 2000. Susan Schwartzenberg, from *Hollow City*.

Three panoramas of Union Square during and after the fire. **Plate 1A.** "The Burning of San Francisco, April 18, view from St. Francis Hotel," 1906. Pillsbury Picture Company. Library of Congress. **1B.** "From St. Francis Hotel," 1906. Pillsbury Picture Company. Library of Congress. **1C.** "Panorama of Union Square from the roof of the St. Francis Hotel," 2003. Mark Klett with Michael Lundgren.

Plate 2A. "The view from the Ferry Tower," 2003. Mark Klett with Michael Lundgren. **2B.** "Market St. from Ferry," 1906. Photographer unknown. The Bancroft Library, University of California, Berkeley.

Plate 3A. "The Ferry Building from the Embarcadero," 2004. Mark Klett with Michael Lundgren. **3B.** "East St., a few weeks after the fire. U.S. Army men bivouacked in tents," 1906. Photographer unknown. The Bancroft Library, University of California, Berkeley.

Plate 4A. "The refurbished Call Building from the front of the Virgin Record store, Market Street," 2003. Mark Klett with Michael Lundgren. **4B.** Untitled, 1906. Stewart & Rogers. The Bancroft Library, University of California, Berkeley.

Plate 5A. "The Call Building with Deco façade, Market and Third Streets," 2003. Mark Klett with Michael Lundgren. **5B.** "Burning of the Call Building. Lotte's [sic] Fountain," 1906. W. J. Street. The Bancroft Library, University of California, Berkeley.

Plate 6A. "Hearst Building, Market Street," 2003. Mark Klett with Michael Lundgren. **6B.** Untitled (Remains of the Hearst Building at Market Street and Third Street), 1906. Arnold Genthe. Cellulose nitrate negative, 135 x 78 mm (5-5/16 x 3-1/16 in.) irreg. Fine Arts Museums of San Francisco, Museum Purchase, James D. Phelan Bequest Fund, A355907.

Plate 7A. "The Palace Hotel from the middle of Geary Street," 2003. Mark Klett with Michael Lundgren. **7B.** "Palace Hotel," 1906. Rhea Brothers. Stephen Wirtz Gallery, San Francisco.

Plate 8A. "Bike messenger hangout, Donahue Memorial, Market Street and Battery," 2003. Mark Klett with Michael Lundgren. **8B.** "Donahue Fountain, May 19, 1906." Turrell and Miller. The Bancroft Library, University of California, Berkeley.

Plate 9A. "Panorama view from near Turk and Market," 1906. Pillsbury Picture Company. Library of Congress. **9B.** "Sidewalk panorama from across the intersection of Market and Turk Streets," 2003. Mark Klett with Michael Lundgren.

Plate 10A. "Flood Building and Urban Outfitters, corner of Powell and Ellis Streets," 2003. Mark Klett with Michael Lundgren. **10B.** "Flood Building," 1906. Photographer unknown. The Bancroft Library, University of California, Berkeley.

Plate 11A. "The intersection of Post and Kearny from the middle of the Kearny Street crossing," 2003. Mark Klett with Michael Lundgren. **11B.** "Post St. and Kearney [sic]," 1906. Photographer unknown. The Bancroft Library, University of California, Berkeley.

Plate 12A. "Mills Building, Montgomery and Bush Streets," 2004. Mark Klett with Michael Lundgren. **12B.** Untitled, 1906. Photographer unknown. The Bancroft Library, University of California, Berkeley.

Plate 13A. "Taxis along California Street, Kohl Building," 2003. Mark Klett with Michael Lundgren. **13B.** "Kohl Building," 1906. Photographer unknown. The Bancroft Library, University of California, Berkeley.

Plate 14A. " 'Relocation Sale,' corner of Powell and O'Farrell Streets," 2003. Mark Klett with Michael Lundgren. **14B.** "Powell & O'Farrell Sts.," n.d. Rhea Brothers. Stephen Wirtz Gallery, San Francisco.

Plate 15A. "Cable car line, corner of Geary and Powell Streets," 2003. Mark Klett with Michael Lundgren. **15B.** "Powell St. near Geary, fire effect," 1906. Photographer unknown. The Bancroft Library, University of California, Berkeley.

Plate 16A. "Waiting hotel van, corner of Stockton and Geary Streets," 2004. Mark Klett with Michael Lundgren. **16B.** Untitled, 1906. J. D. Givens. Stephen Wirtz Gallery, San Francisco.

Plate 17A. "Lunch time, Union Square and the St. Francis Hotel, looking west," 2003. Mark Klett with Michael Lundgren. **17B.** Untitled, 1906. Photographer unknown. The Bancroft Library, University of California, Berkeley.

Plate 18A. "Panorama of Union Square, with Mendenhall's 1906 view embedded," 2003. Mark Klett. **18B.** *Embedded in panorama:* "Baggage salvaged from the St. Francis Hotel, 1906." W. C. Mendenhall. U.S. Geological Survey.

Plate 19A. "Drinking fountain at the east end of Union Square," 2004. Mark Klett with Michael Lundgren. **19B.** Untitled, 1906. Photographer unknown. Stephen Wirtz Gallery, San Francisco.

Plate 20A. "Post and Stockton from the right turn lane," 2003. Mark Klett with Michael Lundgren. **20B.** "Looking down Post St., piles of bricks cleaned off and ready to be re-used. Shreve Building, corner of Grant and Post," 1907. Photographer unknown. The Bancroft Library, University of California, Berkeley.

Plate 21A. "Moving van, Sacramento Street near Powell," 2003. Mark Klett with Michael Lundgren. **21B.** Untitled (View of fire down Sacramento Street), 1906. Arnold Genthe. Negative of unknown film type, 122 x 171 mm (4-13/16 x 6-3/4 in.). Fine Arts Museums of San Francisco, Museum Purchase, James D. Phelan Bequest Fund, A355748.

Plate 22A. "Clay Street near old Chinatown," 2003. Mark Klett with Michael Lundgren. **22B.** Untitled (Burning San Francisco, looking to the east from Clay Street), 1906. Arnold Genthe. Cellulose nitrate negative, 132 x 84 mm (5-3/16 x 3-5/16 in.) irreg. Fine Arts Museums of San Francisco, Museum Purchase, James D. Phelan Bequest Fund, A355784.

Plate 23A. "Dolores Park," 2004. Mark Klett with Michael Lundgren. **22B.** "From the old Jewish Cemetery, 18th and Dolores Streets. The morning of the Great Earthquake and Fire, April 18th, 1906. The Mission High School is in the center. See the home opposite the school the under pinnings have given away [sic]." Photographer unknown. The Bancroft Library, University of California, Berkeley.

Plate 24A. "The edge of Lafayette Park," 2003. Mark Klett with Michael Lundgren. **24B.** "Lafayette Square at dusk," 1906. Photographer unknown. The Bancroft Library, University of California, Berkeley.

Plate 25A. "Steps, 821 Leavenworth," 2003. Mark Klett with Michael Lundgren. **25B.** "Stairs that lead to nowhere (after the fire)," 1906. Arnold Genthe. Negative of unknown film type, 125 x 124 mm (4-15/16 x 4-7/8 in.). Fine Arts Museums of San Francisco, Museum Purchase, James D. Phelan Bequest Fund, A355751.

Plate 26A. "View east from the View Tower Apartment Building, Russian Hill," 2004. Mark Klett with Michael Lundgren. **26B.** "Telegraph Hill and North Beach, wiped out by fire. Around Lombard and Taylor Sts.," 1906. Photographer unknown. The Bancroft Library, University of California, Berkeley.

Plate 27A. "View south from Alta Plaza Park," 2003. Mark Klett with Michael Lundgren. **27B.** "Looking south on Pierce St. from Alta Plaza, ruins of St. Dominic's Church," 1906. Turrell and Miller. The Bancroft Library, University of California, Berkeley.

Plate 28A. "Home at 2020 Jackson Street," 2003. Mark Klett with Michael Lundgren. **28B.** Untitled (E. S. Heller home, 2020 Jackson Street), 1906. Arnold Genthe. Cellulose nitrate negative, 84 x 144 mm (3-5/16 x 5-11/16 in.) irreg. Fine Arts Museums of San Francisco, Museum Purchase, James D. Phelan Bequest Fund, A355859.

Plate 29A. "Sidewalk at 2360 Union Street near Pierce," 2004. Mark Klett with Michael Lundgren. **29B.** Untitled (Earth slip on San Francisco's Union Street), 1906. Arnold Genthe. Cellulose nitrate negative, 110 x 79 mm (4-5/16 x 3-1/8 in.) irreg. Fine Arts Museums of San Francisco, Museum Purchase, James D. Phelan Bequest Fund, A355753.

Plate 30A. "South Van Ness at Seventeenth Street," 2003. Mark Klett with Michael Lundgren. **30B.** "Howard St. between 17th and 18th," 1906. Photographer unknown. The Bancroft Library, University of California, Berkeley.

Plate 31A. "Drugstore, corner of Bush and Fillmore Streets," 2004. Mark Klett with Michael Lundgren. **31B.** Untitled (Corner of Bush and Fillmore Streets with St. Dominic's in the rear), 1906. Arnold Genthe. Cellulose nitrate negative, 133 x 86 mm (5-1/4 x 3-3/8 in.) irreg. Fine Arts Museums of San Francisco, Museum Purchase, James D. Phelan Bequest Fund, A355867.

Plate 32A. "Panorama of Nob Hill from the steps of Huntington Park, with Genthe's 1906 view embedded," 2004. Mark Klett with Michael Lundgren. **32B.** *Embedded in panorama:* Untitled (Shattered stone lion which decorated a stairway in pre–fire and earthquake days), 1906. Arnold Genthe. Cellulose nitrate negative, 124 x 84 mm (4-7/8 x 3-5/16 in.) irreg. Fine Arts Museums of San Francisco, Museum Purchase, James D. Phelan Bequest Fund, A355809.

Plate 33A. "Portals of the Past, frontal view, Golden Gate Park," 2003. Mark Klett with Michael Lundgren. **33B.** Untitled (View of devastated San Francisco, framed between remaining portals of Towne Mansion on Nob Hill), 1906. Arnold Genthe. Cellulose nitrate negative, 149 x 84 mm (5-7/8 x 3-5/16 in.) irreg. Fine Arts Museums of San Francisco, Museum Purchase, James D. Phelan Bequest Fund, A355879.

Plate 34A. "Portico of the Towne Mansion, moved to Lloyd Lake, Golden Gate Park," 2003. Mark Klett with Michael Lundgren. **34B.** "A. N. Towne Residence, View from the Chas. Crocker Residence—California Street," ca. 1905. Photographer unknown. The Bancroft Library, University of California, Berkeley.

Plate 35A. "Grace Cathedral, California and Jones Streets," 2003. Mark Klett. **35B.** "North side California St. from Jones St., Feb. 7, 1907. Henry Crocker home ruins. Grace Cathedral embryo." Turrell and Miller. The Bancroft Library, University of California, Berkeley.

Plate 36A. "Portsmouth Square," 2003. Mark Klett with Michael Lundgren. **36B.** Untitled (Northwest from Kearny through Portsmouth Square), 1906. Arnold Genthe. Cellulose nitrate negative, 81 x 140 mm (3-3/16 x 5-1/2 in.) irreg. Fine Arts Museums of San Francisco, Museum Purchase, James D. Phelan Bequest Fund, A355854.

Plate 37A. "Mission Dolores," 2003. Mark Klett with Michael Lundgren. **37B.** "Dolores Mission, SW corner of 16th and Dolores St.," 1906. Photographer unknown. The Bancroft Library, University of California, Berkeley.

Plate 38A. "Jefferson Square with the steeple of St. Mark's Lutheran Church," 2003. Mark Klett with Michael Lundgren. **38B.** Untitled (Earthquake refugee camp in park), 1906. Arnold Genthe. Cellulose nitrate negative, 84 x 146 mm (3-5/16 x 5-3/4 in.) irreg. Fine Arts Museums of San Francisco, Museum Purchase, James D. Phelan Bequest Fund, A355848.

Plate 39A. "Ball field, Moscone Recreation Center," 2004. Mark Klett with Michael Lundgren. **39B.** "Camp 8, Lobos Square," 1906. Weidner Photo, S.F. The Bancroft Library, University of California, Berkeley.

Plate 40A. "Former refugee camp, now a playground, the Presidio," 2003. Mark Klett with Michael Lundgren. **40B.** Untitled (Woman greets mounted soldier in the Presidio in post fire and earthquake), 1906. Arnold Genthe. Cellulose nitrate negative, 87 x 146 mm (3-7/16 x 5-3/4 in.) irreg. Fine Arts Museums of San Francisco, Museum Purchase, James D. Phelan Bequest Fund, A355895.

Plate 41A. "Carousel, Golden Gate Park," 2003. Mark Klett with Michael Lundgren. **41B.** "Children's Playground GG Park," 1906. George McComb. Stephen Wirtz Gallery, San Francisco.

Plate 42A. "The band shell and the edge of the construction zone for the new de Young museum, Golden Gate Park," 2004. Mark Klett with Michael Lundgren. **42B.** "Band Stand in Golden Gate Park," 1906. Miles Brothers. The Bancroft Library, University of California, Berkeley.

Plate 43A. "Interior of the Stanford University Chapel," 2004. Mark Klett with Michael Lundgren. **43B.** Untitled, 1906. Photographer unknown. The Bancroft Library, University of California, Berkeley.

Plate 44A. "Walkway, Stanford University," 2003. Mark Klett with Michael Lundgren. **44B.** "Agassiz statue at Stanford, April, 1906," 1906. W. C. Mendenhall. U.S. Geological Survey.

Plate 45A. "Righted monument, Holy Cross Cemetery," 2003. Mark Klett with Michael Lundgren. **45B.** "Overthrown monument," 1906. Photographer unknown. The Bancroft Library, University of California, Berkeley.

Plate 46A. "Barn at the headquarters of Point Reyes National Seashore," 2003. Mark Klett with Michael Lundgren. **46B.** "Southeast corner of barn moved northwest to its present location, from post on man's foot," 1906. Photographer unknown. The Bancroft Library, University of California, Berkeley.

Plate 47A. "Rebuilt church, Fort Ross State Historic Park," 2004. Mark Klett with Michael Lundgren. **47B.** "Old Russian Church, Ft Ross—after," 1906. Photographer unknown. The Bancroft Library, University of California, Berkeley.

Plate 48A. "Oak tree in covered fault line, Point Reyes National Seashore," 2003. Mark Klett with Michael Lundgren. **48B.** "Fault trace 2 miles north of the Skinner Ranch at Olema. View is north," 1906. Grove Karl Gilbert. U.S. Geological Survey.

Book design and composition: Nola Burger
Cartography: Ben Pease
Text type: Univers Light
Display type: Bauer Bodoni, Univers Light 45 and Bold 65
Paper: 150gsm Euroart matte art
Printing and binding: Imago, Singapore